BLACK ELK
PEAK

—— A History ——

B RADLEY S AUM

THE
History
PRESS

Published by The History Press
Charleston, SC
www.historypress.net

First published 2017

Manufactured in the United States

ISBN 9781625858702

Library of Congress Control Number: 2016961718

CONTENTS

CONTENTS

INTRODUCTION

Known to the Sioux as Hinhan Kaga (Making of Owls), the highest point in the Black Hills of South Dakota is considered sacred ground. As the Europeans started to traverse the Black Hills in the middle of the nineteenth century, this granite high point was named Harney Peak in honor of General William Harney. About 150 years later, the U.S. Board on Geographic names officially changed the name to Black Elk Peak in honor of the Sioux holy man Nicholas Black Elk.

Up on Black Elk Peak, a great Native American vision was received, a famous general nearly took the summit by horseback and Wasicu Wakan was laid to rest. An enormous rock monument was contemplated, planes were guided through the night and a stone fire tower capped the peak.

The high point represents significantly more than the rugged granite rock may first suggest. The Black Hills of South Dakota, called Paha Sapa by the Sioux, form a sentinel around its highest point. At 7,242 feet, Black Elk Peak is a natural, historical and cultural gem just waiting to be revealed.

On the surface, the magnificent stone fire tower stands as a crescendo to all the curiosities associated with the peak. The historical and architectural significance of the massive structure, built by the Civilian Conservation Corps, dominates the extraordinary events that unfolded on the peak. Looking beyond the man-made stone configuration that rises above the granite, a multitude of other stories unravels at the summit.

With a fascinating glimpse into novel aspects of history, the chronicles of Black Elk Peak provide a launch pad for exploring and learning. Insight into

Native American culture, geology, American history, forest fires, aeronautic navigation, triangulation stations and prominent historical figures are all encapsulated in this one peak in the Black Hills.

The natural beauty of the pinnacle is unmistakable. The commanding view overlooking the Black Hills lured many to the summit. The geologic formations attracted others. The prominent height stood as a challenge to many. A fascination with the peak has drawn a wide array of interest from scientists, entrepreneurs, tourists, historians, artists, naturalists, authors and even several United States government agencies.

Black Elk Peak is certainly not one of the most easily accessible places in the Black Hills. There is no close parking lot with a conveniently paved walking path to accommodate the casual visitor. The effort expended to trek the rugged miles makes the adventure a toll of sorts paid for the privilege that awaits at the top. The appreciation of and respect for the summit are earned through each step along the trail. Black Elk Peak is undoubtedly a unique and special place.

The climb to the summit begins as a casual stroll and quickly evolves with each step to demand reverence for those who preceded. Outcroppings along the trail offer sneak peeks of the summit off in the distance, a tease that entices the trek to continue. The grand finale at the summit is merely the stage.

The visitors who trek to the summit of Black Elk Peak seek the natural beauty amplified by the unique views of the Black Hills. As a lighthouse guides ships to port, the highest point in South Dakota draws people to stand afoot rock that formed 1 billion years ago, appreciate the surrounding landscape and consume the ambiance shared by every person lured to the summit throughout history.

As the most fascinating peak in the Black Hills, thousands of people have stood on Black Elk Peak and peered out toward the horizon, absorbing the beauty laid before them. For many, this is sufficient, and they move on to other things. But for others, the walk to the summit generates many questions and the desire to learn more about the history and culture that supplements the natural beauty of the highest peak.

Certainly not intended as an exhaustive study on every subject approached, rather, the following chapters contain a unique collection of well-researched facts presented to provide insight and perspective into this distinctive peak. Many of the following chapters demand a complete book dedicated to the subject, and in some instances, such thorough books exist. Other chapters contain facts that were discovered hidden only in

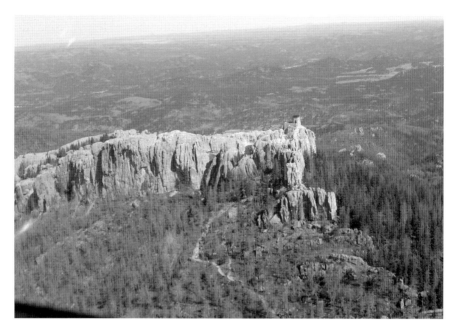

Black Elk Peak, capped with a stone fire lookout tower, stands prominently as the highest point in the Black Hills of South Dakota. *Photo by Bradley D. Saum.*

primary sources, patiently waiting to be revealed in this text. The brief forays contained in this book afford just a glimpse into the detail, but when viewed as a whole, they offer an interpretation worthy of the highest peak in the Black Hills.

The story of Black Elk Peak has previously remained largely segmented and scattered throughout the shadows of history. Individually, the isolated references to Black Elk Peak do not serve justice to the granite thrust upward from the earth millions of years ago. When the unique and curious events that unfolded throughout history are revealed, the high point of the Black Hills garners a remarkable appreciation.

The author first encountered the high point following an upward climb along Trail Number 9. Silently absorbing the view that contains a significant portion of the Black Hills, it was evident that there was a story to tell—more like an invitation to learn about the history and share in the respect, admiration and appreciation of the high point.

The remarkable history of Black Elk Peak is captured here and reveals the natural, historical and cultural gem that stands prominently over the Black Hills.

New Name

A heartfelt letter taking exception to the name Harney Peak was written in 2014 by Basil Brave Heart of Pine Ridge, South Dakota, and served as the spark that ignited a broad discussion eventually resulting in a name change for the highest point in the Black Hills. Basil Brave Heart, a member of the Oglala Lakota tribe and also a Korean War veteran, wanted the peak be named after Black Elk, a respected Sioux holy man.

United States president Barack Obama drew attention to the subject of naming geographic locations significant to Native American cultures in the fall of 2015 when he announced that Mount McKinley in Alaska was being renamed Denali. With a campaign that began some thirty years before, the national park surrounding the peak was named Denali in a 1980 compromise of sorts, but the actual peak remained Mount McKinley.

Although the tallest peak in North America was named in honor of President William McKinley, he had never visited the area and had no specific connection to the high point. With Denali typically translated as the "Great One," the native Koyukon Athabascan people referred to the mountain as such. The majestic summit is central to the beliefs and culture about their origins.

Known for many generations as Denali and then renamed Mount McKinley for nearly one hundred years, the rugged high point in the Alaska Range was officially returned to the original Denali name in 2015.

The name of the highest peak in South Dakota would follow a similar path. The Black Hills of western South Dakota, and specifically the highest

peak, are sacred to the Sioux. There is a long history of the Sioux culture interconnected with the Black Hills, and this land is a critical element in their spiritual identity. The highest point was known as Hinhan Kaga and was considered the center of the spiritual universe.

The Native American name Hinhan Kaga was eventually replaced as Europeans entered the region. Lieutenant General Gouverneur K. Warren was exploring the area in 1857 and took the liberty of naming the high point Harney Peak in honor of General William S. Harney, commander of the military in the Black Hills region. Although the expedition into the Black Hills by Lieutenant General Warren was at the request of General Harney, he did not accompany Warren. There is no record that General Harney was ever at the peak named in his honor or even traversed through the heart of the Black Hills in proximity to the high point.

In response to the correspondence from Basil Brave Heart, the South Dakota Board on Geographic Names solicited comments in the spring of 2015 on a proposed name change for Harney Peak. Public meetings were held, and written comments were also accepted. On May 7, 2015, the board voted unanimously to recommend the name be changed to "Hinhan Kaga (Making of Owls)." However, following a thirty-day comment period and more than three hundred comments against the change, the state board reconsidered and voted four to one to retain the existing Harney Peak name.

The U.S. Board on Geographic Names is responsible for establishing uniform usage of geographic names throughout the federal government and has been operating since 1890. The recommendation of the South Dakota state board was escalated to the federal board. There is a federal policy allowing for name changes when a name is shown to be highly offensive or derogatory to a particular racial or ethnic group, gender or religious group.

The history of General Harney records a ruthless leader willing to go to extremes for his cause. During the Battle of Blue Water Creek in 1855, under the leadership of General Harney, eighty-six Sioux were killed and many others captured. The Native American village was looted and destroyed. The fight became known as the Harney Massacre. General Harney was avenging an earlier attack by the Sioux against Lieutenant John Grattan near Fort Laramie.

The federal board of twelve voted unanimously, and after 110 years as officially designated Harney Peak, the name was formally changed to Black Elk Peak on August 11, 2016. The board indicated that the name Harney Peak was concerning to Native Americans.

The new name honors Nicholas Black Elk, whose Native American name was Hehaka Sapa; he was a renowned spiritual leader among the Sioux who lived until the middle of the twentieth century. Black Elk had many visions that are central to the Sioux culture and provided intense insight and guidance as a holy man of the Oglala Lakota Sioux.

The name Black Elk Peak not only honors Black Elk but also serves to recognize and preserve the spiritual significance in the Native American culture of the highest point in the Black Hills.

Positioned Among Parks

Speckled and surrounded by a gaggle of parks, forests and reserves, Black Elk Peak is well insulated from encroachment. There are many designations that incorporate the summit, and each one provides a layer of specific regulations. The protections afforded to the remote Black Elk Peak have aided in preservation and accessibility.

The premier high point of western South Dakota, the summit of Black Elk Peak is the pinnacle of the Black Hills National Forest. Encompassing 1.25 million acres, the Black Hills National Forest is managed by the U.S. Forest Service and includes an area roughly 125 miles long and 65 miles wide.

The Black Hills Forest Reserve was originally designated by President Grover Cleveland in 1897, several years after a series of devastating wildfires. When the forest service was formally created in 1905, this reserve that includes Black Elk Peak was transferred to the new agency under the Department of Agriculture. Harney National Forest was established in 1911, and when later added to the Black Hills National Forest, the Harney name for the national forest was discontinued.

The U.S. Forest Service manages 154 national forests and twenty grasslands with a mission to sustain the health, diversity and productivity of the nation's forests and grasslands to meet the needs of present and future generations. There are almost 200 million acres of public land under the management of the U.S. Forest Service.

Just over 50 percent of the U.S. Forest Service budget is dedicated to wildfire. Resources—such as firefighters, aircraft, vehicles and other

equipment—are needed to protect lives, property and natural resources from catastrophic wildfires.

Offering stringent protections, Black Elk Peak is the cornerstone of the Black Elk Wilderness Area, which includes the summit and the surrounding 13,426 acres. The wilderness area designation limits the human influence to the ecosystem, prohibits mechanized equipment and bars logging and drilling. Originally established by Congress in 1980, and later expanded to its current size in 2002, there are no roadways traversing the Black Elk Wilderness.

President Lyndon B. Johnson signed the Wilderness Act into law on September 3, 1964. The National Wilderness Preservation System was one component of this law, and more than 100 million acres have been designated as wilderness areas under the management of a variety of government agencies. The Black Elk Wilderness Area is among the 445 designated wilderness areas managed by the U.S. Forest Service.

Remaining as the focal point, Black Elk Peak is surrounded by the Norbeck Wildlife Preserve. The twenty-seven-thousand-acre preserve is intended to protect game animals and birds and ensure that wildlife breeding lands remain intact. Norbeck Wildlife Preserve was established by Congress in 1920 and named in honor of Peter Norbeck, a South Dakota governor and later a senator who was instrumental in both developing and preserving the Black Hills for tourism.

Nearly four miles from the summit, the trailhead typically used to reach Black Elk Peak is located within Custer State Park. Managed by the South Dakota Department of Game, Fish and Parks, Custer State Park is adjacent to the southern boundary of the Black Elk Wilderness. Custer State Park includes seventy-one-thousand acres and is perhaps best known for its herd of more than 1,500 free-roaming bison. The Civilian Conservation Corps was extremely active in the park during the Great Depression building roads, campgrounds and dams.

Sylvan Lake, part of Custer State Park, has evolved into a resort area that includes a lodge, cabins, campground and restaurant. The trailhead for the most popular route to Black Elk Peak is located in the large parking lot on the east side of Sylvan Lake.

Another designation, the Harney Peak Wilderness Area, was proposed in 1979. H.R. 5302 was referred to committee and never gained traction.

Within the shadow of Black Elk Peak, the Upper Pine Creek Research Natural Area rests in the Black Elk Wilderness. Just northeast of Black Elk Peak, the 850 acres of the Research Natural Area is part of a national

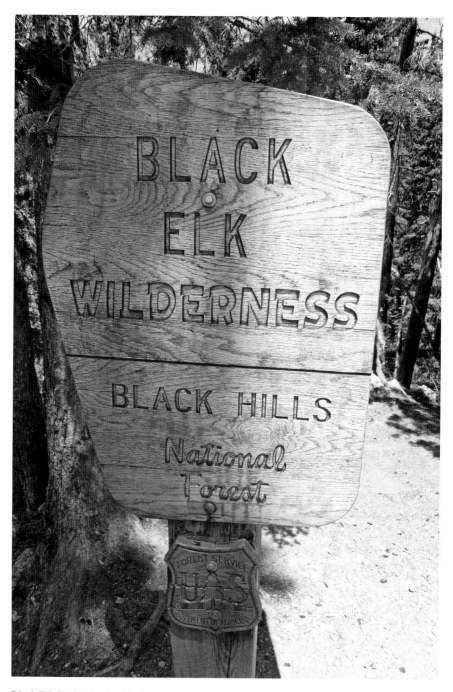

Black Elk Peak is in the Black Elk Wilderness, which is located in the Black Hills National Forest in western South Dakota. *Photo by Bradley D. Saum.*

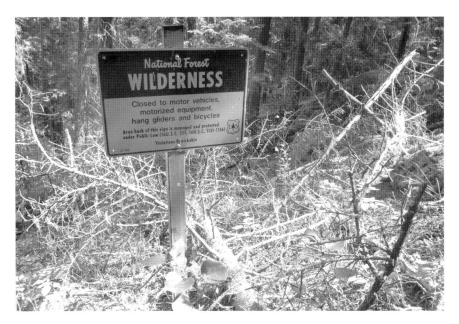

Road construction and motorized vehicles are prohibited in designated wilderness areas. Black Elk Peak is part of the National Wilderness Preservation System, established by Congress in 1964. *Photo by Bradley D. Saum.*

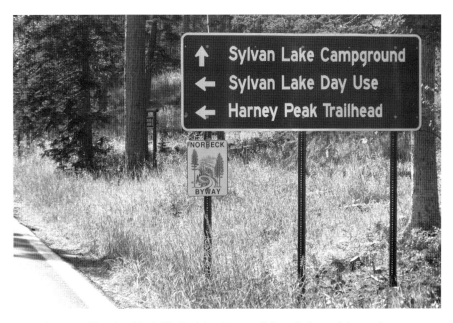

The primary trailhead to Black Elk Peak begins near Sylvan Lake, and due to the recent name change in 2016, some maps and directional signage may still read as "Harney Peak." *Photo by Bradley D. Saum.*

The Black Hills National Forest encompasses more than 1.25 million acres in western South Dakota and is managed by the U.S. Forest Service. *Photo by Bradley D. Saum.*

network of ecological areas designated in perpetuity for non-manipulative research, education and biodiversity conservation.

Black Elk Peak is located in southern Pennington County within the state of South Dakota, United States of America. Precise coordinates are 43°51′58″N 103°31′54″, commonly formatted as W43.86611°N 103.53167°W.

The multiple layers of protection from federal and state agencies have proven beneficial, as Black Elk Peak remains largely untouched, the only exception being the stone fire tower. With no roads permitted in the Black Elk Wilderness, the direct impact from visitors is relatively limited.

EARLY ASCENTS

The first person to summit Black Elk Peak likely did so long before recorded history. Artifacts such as tools and graves present archaeological evidence to suggest that Native American tribes were settled in the Black Hills as early as nine thousand years ago.

Perhaps the first European people to explore the Black Hills were French fur traders who "discovered" the region in 1743. During the Lewis and Clark Expedition, William Clark logged conversations with Jon Vallie, a French fur trapper. On October 1, 1804, Clark's journal entry indicated that Vallie described very high black mountains up the north fork of the Cheyenne River (the present-day Belle Fourche River).

General George Armstrong Custer attempted to scale Black Elk Peak on July 31, 1874. N.H. Winchell accompanied Custer and four other men on horseback in a strenuous attempt to explore the high point, but they were blocked from reaching the summit by the inaccessible elevation of the granite.

Custer forced his horse through the dense pine trees and up the granite inclines, pushing farther each time toward the highest granite protruding from the Black Hills. Unwilling to dismount for the final scramble to the peak, Custer fell short, and although he was very close, he never actually reached the summit. The ability to reach the top of Black Elk Peak is dependent on scaling the sheer granite, where there is little to no vegetation.

The first recorded ascent to the summit of Black Elk Peak is believed to have been made by Dr. Valentine T. McGillycuddy on July 24, 1875.

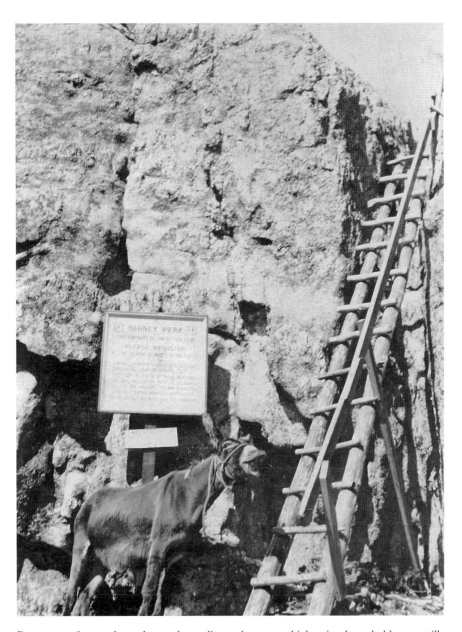

Burros were frequently used to pack supplies to the remote high point, but a ladder was still needed to reach the summit. *U.S. Forest Service.*

Confronted by the same perpendicular cliffs that challenged Custer, McGillycuddy and his companions engineered a ladder from a fallen ponderosa pine tree. The summit was reached by scrambling up the makeshift ladder leaning against the cliff. Part of a scientific expedition that confirmed the presence of gold in the Black Hills, McGillycuddy was then a surveyor for the Newton-Jenney Expedition.

Ladders were used for many years subsequent to that first scramble to the peak. It would be well over fifty years before a solid steel staircase was constructed and stone steps were secured to the granite.

SACRED CENTER

O riginally known as Hinhan Kaga to the Sioux, Black Elk Peak is sacred to the Sioux spiritual life. Hinhan Kaga translates as "sacred dark and frightful owl." With an imaginative eye, visitors may possibly recognize the granite formations resembling the shape of owls, especially after dark, as the shadows influence the view.

Black Elk Peak was a gathering place, or Okawita Paha. The Sioux assembled at Black Elk Peak on the first day of spring to send prayers to all of creation for blessings during the new season. An ancient ceremony during the spring equinox at the summit presents prayers and offerings while in return asking for rain in the right quantities and weather that is not too harsh or dangerous. The legendary Thunderbird, guardian of truth, is said to nest on the peak. Feared for striking down liars with lightning bolts, Thunderbirds were also summoned with tobacco offerings to bring rain.

There is a long tradition of praying at the summit. The peak was known as a *wazipan*, where a person in need could enter and later leave completely fulfilled both physically and spiritually. Hinhan Kaga is also central to the sacred Black Hills Native Americans seeking *hambleycha*, or visions. Detailed descriptions of visions revealed on the granite high point are an important part of Sioux oral history.

By the end of the eighteenth century, the Sioux had become the most dominant regional tribe, with a culture based on the Great Plains bison. The view from Hinhan Kaga encompasses all that had been part of the larger

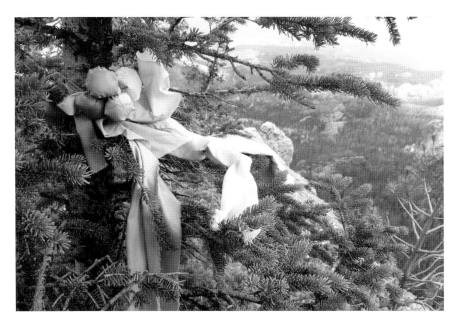

Considered a sacred location to the Sioux, red, yellow or blue prayer cloth is frequently tied to tree branches at the summit of Black Elk Peak. *Photo by Bradley D. Saum.*

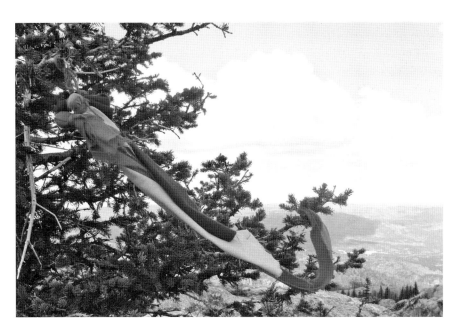

Prayer cloth, also known as prayer ties or prayer flags, can be found in many of the trees at Black Elk Peak overlooking the Black Hills. *Photo by Bradley D. Saum.*

Sioux territory, including present-day states of Wyoming, Nebraska, North Dakota and South Dakota.

Nicholas Black Elk described Hinhan Kaga as the place where the spirits took him in his vision, and many years later, Black Elk returned to the summit and pointed precisely to the granite spot where he had originally stood. He shared the insight he obtained that every facet of being possesses a circular dimension representing a harmony of life, all of which revolve around the highest peak in South Dakota.

Colorful prayer bundles consisting of specific colors are left near the summit to the powers of the six sacred directions. The red cloth represents east, yellow is south, black is west, white is north, tan is earth and blue is sky. These prayer bundles are usually in the form of offerings with tiny bits of herbs wrapped in cloth. The prayer cloth and bundles are tied to tree branches and move freely with the breeze.

Continuing the spiritual revitalization sought on the peak, as well as embracing traditional ceremonies, Hinhan Kaga, the highest point in He Sapa (Black Hills), remains sacred to the Sioux.

BLACK ELK

The rugged granite thrust outward from the earth provides a stage for unyielding views from the plains through the mountains, all of which was once part of the Sioux Nation. It was on this high point that a young Native American received a vision placing Hinhan Kaga, the highest point in western South Dakota, at the center of the world. That granite summit rising above the Black Hills would later be named in honor of that young Sioux, named Nicholas Black Elk.

Black Elk was a remarkable man, a respected leader with diverse experiences who successfully bridged two different lifestyles into one deeply pensive and insightful character. Black Elk was a spiritual leader among the Sioux, lived a traditional nomadic lifestyle and resisted the encroachment of the Europeans into the Sioux territory. However, as his life unfolded, Black Elk became a Catholic, lived within the confinements of Pine Ridge Reservation and performed with the traveling "Buffalo Bill" Cody's Wild West Show.

Black Elk is believed to have been born in December 1863 along the Little Powder River in what is the present state of Wyoming. A second cousin of Crazy Horse, Black Elk witnessed the U.S. Cavalry under the leadership of General Custer engage the Sioux at the Battle of Little Bighorn in 1876, when he was about twelve years old. The following year, his family was encamped with Crazy Horse when he was fatally wounded.

Black Elk and his family fled with other Sioux to join Sitting Bull in Canada but would later return to Pine Ridge Reservation. Black Elk evolved

as a respected shaman, or medicine man, of the Oglala Sioux. Visions, a critical element in the spirituality of the Native American culture, provided Black Elk with insight and guidance.

Black Elk joined Buffalo Bill's Wild West Show, traveling as far as Europe to entertain the onlookers, including a performance for Queen Victoria. While in Europe, he was separated from the rest of the group and eventually started performing with another Wild West show. However, after about three years, he returned to Pine Ridge Reservation in 1889. Black Elk was grazed by a bullet in the Wounded Knee Massacre a year later on the Pine Ridge Reservation while attempting to rescue others who were injured.

Black Elk, namesake of the highest peak in the Black Hills, was a respected Sioux medicine man. *U.S. Department of Agriculture.*

By 1904, Black Elk had converted to Catholicism and taken the name Nicholas Black Elk. He was a devout Catholic and regularly encouraged others to convert to Catholicism. He also helped sponsor the annual Catholic Sioux Congress as a member of the Society of St. Joseph. He was respected as a spiritual leader who successfully merged his traditional beliefs with the Catholic faith.

It was not until much later in his life that Black Elk revealed the vision he received at the young age of nine on the summit of Black Elk Peak. In his native Sioux language, Black Elk described his spiritual life to poet John G. Neihardt, who captured the story and published *Black Elk Speaks* in 1932.

John G. Neihardt accompanied Black Elk to the summit of Black Elk Peak and recorded the spiritual experience that had occurred almost seventy years earlier. Neihardt translated Black Elk's description in his book:

> *I was standing on the highest mountain of them all, and round about beneath me was the whole hoop of the world. And while I stood there I saw more than I can tell and I understood more than I saw; for I was seeing in a sacred manner the shapes of all things in the spirit, and the shape of all shapes as they must live together like one being. And I saw that the sacred hoop of my people was one of many hoops that made one circle, wide as daylight and as starlight, and in the center grew one mighty flowering tree to shelter all the children of one mother and one father. And I saw that it was holy.*

Black Elk routinely participated in the Duhamel family's Sioux Indian Pageant at Sitting Bull Crystal Caverns in western South Dakota during the later years of his life. Having lived well over eighty years, Nicholas Black Elk died in 1950.

When the Sioux elder Basil Brave Heart discussed his desire to change the name of the highest peak in the Black Hills, a great-great-grandson of Black Elk's, Myron Pourier, assisted him in his efforts. That highest mountain, atop which he stood in his vision, is now known as Black Elk Peak. The site remains sacred to Native Americans.

WARREN'S PROCLAMATION

During his 1857 exploration deep into the heart of the Black Hills, Lieutenant General Gouverneur K. Warren is credited with naming the highest summit Harney Peak in honor of General William S. Harney, then commander of the military in the Black Hills region. The name was commonly used and made official in 1906 by the U.S. Board on Geographic Names, and it remained Harney Peak until it was officially renamed Black Elk Peak in 2016.

Scampering through the trees and across the granite on horseback nearly twenty years after Lieutenant General Warren's proclamation, General George Armstrong Custer stopped briefly during his effort to reach the highest peak in the Black Hills on July 31, 1874, and drank from his canteen in recognition of General Harney.

Harney Peak evolved as the undisputed name for the granite high point protruding from the Black Hills for the next 150 years. It was quickly incorporated into maps being published in the late nineteenth century. Harney Peak was identified in *The Historical and Geographical Encyclopedia*, published in 1883 by H.H. Hardesty; *The Indexed Atlas of the World*, published in 1884 by Rand McNally and Company; and *Cram's Unrivaled Atlas of the World*, published by George F. Cram in 1890. The only variation occurring in the name of the summit was an apostrophe, included on some maps as "Harney's Peak" and others as "Harney Peak."

The U.S. Board on Geographic Names made it official on May 2, 1906, designating the summit as Harney Peak and recognizing that it was named in honor of General Harney.

The granite high point was officially recognized as Harney Peak in 1906, a name that remained for more than 150 years. *U.S. Board on Geographic Names, U.S. Geological Survey, U.S. Department of Interior.*

In addition to the atlas references where Harney Peak was standard nomenclature, several local residents were identified on the official submission to the Board on Geographic Names as providing additional validation. The local usage of the name Harney Peak was confirmed by Jacob S. Gantz, county clerk in Pennington County, South Dakota, and John R. Brennan, Indian agent on the Pine Ridge Indian Reservation, the latter of whom is also credited with founding the town of Rapid City, South Dakota, in 1876.

Although named in honor of General Harney, there is no record of the general ever making the ascent to the summit. General Harney skirted the edges of the Black Hills leading a military expedition to Fort Pierre and likely observed the high point far on the horizon.

HARNEY

The highest peak in the Black Hills became known as Harney Peak, in honor of General William S. Harney in 1857, as the European explorers started entering the region. It would remain Harney Peak for the next 159 years until the U.S. Board on Geographic Names officially declared the high point Black Elk Peak.

Instrumental in the history that unfolded during his nearly sixty years of service in the U.S. Army, General Harney is often overshadowed by his more famous colleagues. Intertwined with historical giants Abraham Lincoln, Jefferson Davis, General Andrew Jackson and General William Sherman, General Harney dedicated his life to serving his country.

Harney's military career presents a dichotomy of peace and war, friend and foe, diplomat and agitator, order and rebellion. The legacy of Harney is equally divisive. Undoubtedly, he served his country for nearly sixty years and emerged one of the most famous military leaders of the 1800s. Those were tumultuous years, as the early Europeans gradually made their way west into the new frontier and areas inhabited by Native Americans for thousands of years.

Harney began his military career at the age of seventeen, when he was commissioned second lieutenant in 1818. During the First Seminole War, the Crow people awarded him a Native American name, Man-who-runs-like-the-deer. Although engaged in Native American wars during the bulk of his career, Harney served alongside then captain Abraham Lincoln and then lieutenant Jefferson Davis in the Mexican-American War.

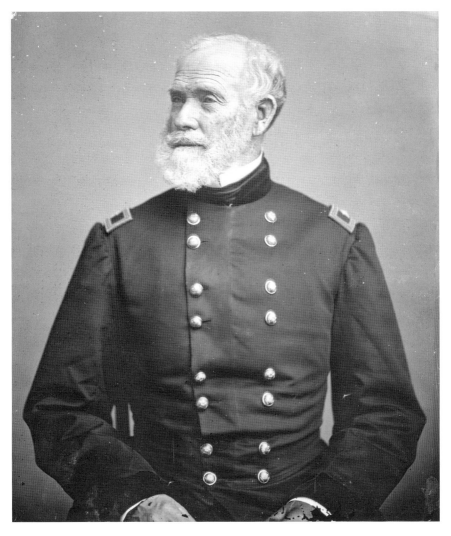

Black Elk Peak was formerly known as Harney Peak and was named in honor of General William S. Harney. *Mathew Brady—U.S. National Archives and Records Administration.*

Harney diverged from the common idea of the day to remove all Native American populations and pursued a good neighbor policy. This enabled him to effectively communicate with the Sioux, but in practice, he was a fierce and dedicated military leader first.

It was in 1855, at the Battle of Ash Hollow, that Harney was responsible for leading his six-hundred-man army in an attack against Native Americans, resulting in the death of eighty-six Sioux, including a number of women and

children. As a devoted military commander, he reported that his intent with this attack was to avenge the deaths of thirty soldiers the previous year at the hands of Native Americans.

Throughout his years with the military, he was known for his angry outbursts and his beatings of subordinates. He was ultimately court-martialed four times, and each time he returned to his continual rise among the ranks. His anger flared against a female slave in 1834, and the day after Harney severely beat her, she died of her injuries.

General Harney skirted the edges of the Black Hills in 1856 en route from Ash Hollow to Fort Laramie. In command of the Department of the West, Harney solicited Lieutenant General Gouverneur K. Warren to explore the Black Hills, which ultimately resulted in the highest peak bearing his namesake.

Both a friend and foe of Native Americans, Harney commanded troops in Bleeding Kansas in 1857 and led the expedition against the Sioux Indians on the Great Plains in 1866. As he was effective at negotiating treaties, Native Americans viewed Harney as instrumental in the Indian Peace Commission. The Sioux later changed his earlier Crow name to Man-who-always-kept-his-word.

Harney continued his efforts to protect the incursion of the European settlers at all cost and gained respect on the frontier. The vicious manner in which he carried out his duties and led his command resulted in continual clashes with the Sioux.

Many places beyond Harney Peak recognize Harney as their namesake. The significance of this one general's diverse and well-known role in American history is amplified by the many places that bear his name, literally from coast to coast.

As the first commander of the U.S. Army's Department of Oregon in 1868, then brevet brigadier General Harney also left his mark on the Northwest. Among his accomplishments, Harney was instrumental in opening eastern Oregon to settlement by building roads and resolving Native American disputes, as well as ensuring that San Juan Island, off the northwest coast, was to become part of the United States, albeit nearly causing a war with Great Britain in the process.

Leaving a permanent mark in Oregon, Harney County in eastern Oregon memorialized the general's contributions to the region and was named in his honor in 1889. A seven-acre park in Portland, Oregon, and Harney City Park in Multnomah County also carry his name, as does Harney Lake in southeast Oregon's Malheur National Wildlife Refuge.

On the opposite coast, General Harney received recognition for his strategic ability to fight the Seminoles in Florida. Keeping his namesake alive in Florida, neighborhoods, a lake and a river are named in honor of the general.

Harney's life was controversial and has routinely generated divisive positions on his actions and the legacy he left behind. Harney died in Orlando, Florida, in 1889 at the age of eighty-eight. The final resting place of General Harney is in Section 1, Plot 111 at Arlington National Cemetery, with a memorial clearly marking his grave.

ENGINEER-EXPLORER

Summoned by General Harney in April 1855 for the Sioux Expedition, Lieutenant General Gouverneur K. Warren would spend the next three years in exploration, cartography and warfare in the Nebraska and Dakota Territories. Warren compiled the first significant documentation of Black Elk Peak, using the detailed observations recorded during his expeditions.

Traversing directly through the Black Hills in 1857, Warren named the high point Harney Peak in honor of his commanding officer, General Harney. The name Harney Peak would remain for the next 150 years, until the high point was renamed Black Elk Peak in 2016.

Compiling his detailed field notes and sketches, Warren created the first detailed map of the Nebraska and Dakota Territories, which included Harney Peak. The mapping efforts were focused on developing potential transcontinental railroad routes. Warren would produce the first comprehensive map of the United States west of the Mississippi River.

The task of compiling field notes and data to generate a map was a painstaking and tedious process that Warren seemed to appreciate. Ultimately, he was responsible for creating the *Map of the Territory of the United States from the Mississippi River to the Pacific Ocean* in 1858.

In his *Preliminary Report of Explorations in Nebraska and Dakota in the Years 1855-'56-'57*, Warren reported the following description: "The highest mountain masses, such as Harney's Peak, on the eastside, are all granite, the rocks, as seen at a distance, appearing in the same unmistakable

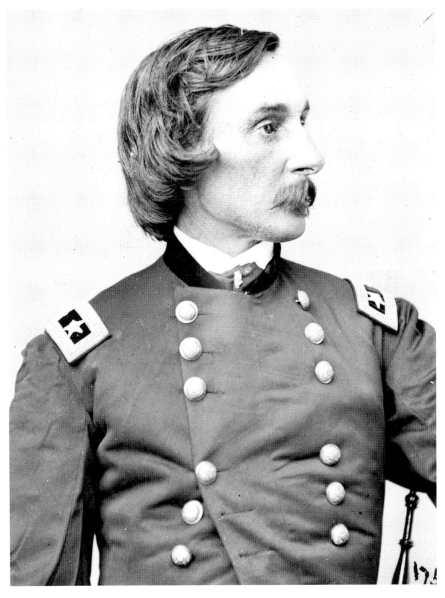

General Gouverneur K. Warren originally named the peak in honor of General William S. Harney in 1857 while exploring the Nebraska and Dakota Territories. *Library of Congress.*

form as those on the Raw Hide and Laramie Peaks, namely, coarse granite or gneiss, standing in layers and slabs, indicating, a vertical stratification."

Following the three years of exploration, Warren assumed a teaching position at the West Point Military Academy as a mathematics professor. He had previously graduated second in his class at West Point in 1850, after entering at the young age of sixteen four years earlier. Warren's military career later experienced a dramatic rise and fall during the American Civil War.

Warren achieved recognition as a prominent general in the Union army, best known for his strategic foresight during the Battle of Gettysburg. Recognizing the importance of an undefended position, Warren ordered troops to Little Round Top, effectively protecting the left flank of the Union army. He was promoted to major general on August 8, 1863, following the battle.

However, at the Battle of Five Forks on April 1, 1865, as commander of the U.S. Army V Corps, Warren received criticism from General Philip Sheridan. Perceiving the V Corps as advancing too slowly, Sheridan became enraged when Warren was not at the front of his advancing columns. Although the attack by the V Corps was victorious, Sheridan lost confidence in his abilities and relieved Warren of his command as the battle was ending.

For the remainder of his career, Warren continually tried to exonerate his name. Some fourteen years later and three months after Warren died, a court of inquiry directed by President Rutherford B. Hayes concluded that Sheridan should not have relieved him of command following the Battle of Five Forks.

Warren spent the rest of his military career as an engineer, resulting in seventeen years as a major in the Corps of Engineers, and was eventually promoted to the rank of lieutenant colonel in 1879. He was involved with railroad construction and focused on assignments along the Mississippi River. Upon his death in 1882, he was buried in civilian clothes and without military honors in Newport, Rhode Island, which he had previously requested. Warren was only fifty-two years old when he died of acute liver failure related to diabetes.

Warren's contribution to the Battle of Gettysburg is recognized with a bronze statue on Little Round Top within Gettysburg National Military Park. With stone quarried from Little Round Top as the granite base, another statue of Warren is located in the Grand Army Plaza, Brooklyn, New York.

CUSTER

Believed to be harboring economic wealth, the uncharted area of the Dakota Territory known as the Black Hills lured General George Armstrong Custer. In 1874, a most unusual expedition ventured into the region on rumors of gold.

Under the leadership of General Custer, one thousand men, two thousand animals and 110 wagons traveled nearly three hundred miles to spend fewer than twenty-six days in the Black Hills. While camped near the present city of Custer, a small group led by General Custer set off to explore the highest summit of the Black Hills, known then as Harney Peak.

The barren granite peak eluded the dedicated general, who tried multiple times to circumvent the rocky barrier and force his mount higher. Inaccessible by horseback, the general stopped just short of the summit and drank from his canteen to the health of General William S. Harney, then namesake of the Black Hills high point. Although stopping just short of the granite protruding as the highest point, General Custer later reported that he had made it to the crest of Harney Peak.

While General Custer was away from camp exploring Black Elk Peak, whiskey and cigars highlighted the party that developed among the majority that had remained behind. Delayed by the repeated attempts to reach the summit of Black Elk Peak, the excursion led by General Custer did not return until well after midnight to a sleeping camp.

Validating the rumors, Horatio N. Ross found gold in a nearby creek, and word spread rapidly of the discovery. Several of the explorers even staked

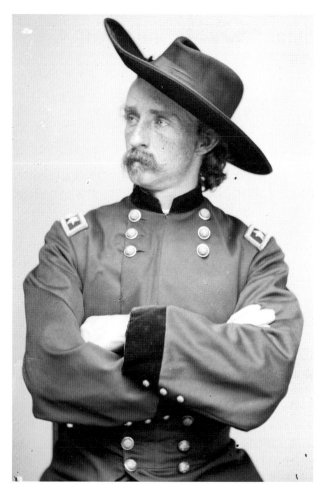

Left: General George Armstrong Custer nearly reached the summit of Black Elk Peak on horseback while exploring the Black Hills in 1874. *Library of Congress.*

Below: It was during Custer's expedition in 1874 into the Black Hills that he attempted to reach Black Elk Peak on horseback. *National Park Service, Little Bighorn Battlefield National Monument.*

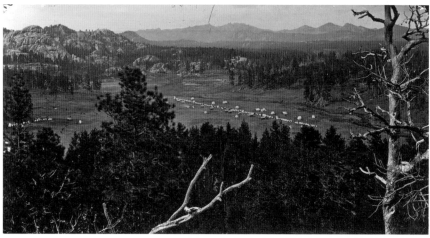

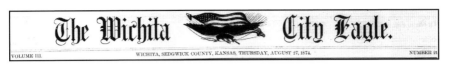

The Wichita City Eagle.

VOLUME III. WICHITA, SEDGWICK COUNTY, KANSAS, THURSDAY, AUGUST 27, 1874. NUMBER 21

A dispatch written by General Custer reporting on the progress of the Black Hills Expedition, published in the Wichita, Kansas newspaper on August 27, 1874, references Harney Peak. *From the* Wichita City Eagle.

gold claims in Custer Gulch, about seven miles south of Black Elk Peak. These claims were reservations of sorts, as the Black Hills still belonged to the Sioux. Regardless, the Black Hills Gold Rush began as thousands of people gradually ventured into the mountains of the Dakota Territory seeking the treasure.

A dispatch from General Custer appeared in the *Wichita City Eagle* of Wichita, Sedgwick County, Kansas, on Thursday, August 27, 1874, reporting progress of the Black Hills expedition:

> *On the 30th we moved in the direction of our previous course and through a fine, open country, covered with excellent grazing. After a march of ten miles, we encamped early in the day, about five miles from the western base of Harney's Peak, finding water and grass and wood abundant, with clear, cold springs of water running through the camp. The following day the command remained in the camp, except the exploring parties sent out in all directions. With a small party I proceeded to Harney's Peak, and after great difficulty made the ascent to the crest. We found this to be the highest point in the Black Hills. From the highest point we obtained a view of Bear Butte, in the north part of the plains to the east, far beyond the Cheyenne river. Our party did not reach camp until near 1 o'clock that night, but we were amply repaid for our labors by the magnificence of the view obtained. While on the highest point, we drank to the health of the veteran out of compliment to whom the peak was named.*

Custer gained respect during the Civil War. He was just finishing his studies at West Point at the start of the Civil War, and the school actually graduated his class one year early in 1861 so they could participate in the war. Although he finished last in his class at West Point, he became known as an aggressive cavalry brigade commander who was willing to take personal risks.

As the Civil War was ending in 1865, Custer held the rank of major general and commanded an entire cavalry division. After the conclusion of

the war, he was sought for his skill as a cavalry commander to fight in the American Indian Wars.

Two years after Custer led the Black Hills Expedition, the Battle of the Little Bighorn occurred on June 25, 1876, about 250 miles to the northwest of the Black Hills. A coalition of Native Americans led by Crazy Horse and Chief Gall decisively defeated Custer and his Seventh Calvary Regiment in what became known as "Custer's Last Stand." When the dust settled, Custer, along with 262 other soldiers and approximately 80 Sioux and Cheyennes, lay dead on the battlefield.

General Custer was born in New Rumley, Ohio, on December 5, 1839. He died at the young age of thirty-seven and was initially buried at the battlefield, but he was later interred at the West Point Cemetery.

MOUNTAIN MONUMENT

Inspired by the granite solidly positioned under his feet and the vista nearly whispering to him, it was atop Black Elk Peak that sculptor Gutzon Borglum made the decision. Borglum scouted the area around Black Elk Peak in search of a granite outcropping suitable for sculpture. While at the summit of Black Elk Peak, he declared on August 14, 1925, that he would carve American history into the skyline that lay just to the northeast.

And the skyline that sparkled Borglum's eye contained a burst of Harney Peak granite peppered with ponderosa pine trees that he had explored on the previous day, known locally as Mount Rushmore. Protruding to a height of 5,725 feet above sea level, the peak was long known as Six Grandfathers to the Sioux.

The granite summit selected for the mountain carving was named in the 1880s when Charles E. Rushmore, a New York attorney, was in the Black Hills checking land claims. During his visit, Rushmore asked his local guide, Bill Challis, the name of the mountain they were passing. Challis replied something to the effect of, "Never had a name but from now on we'll call it Rushmore." The U.S Board of Geographic Names officially recognized the name Mount Rushmore in June 1930.

Located near the small mining town of Keystone, the granite forming Mount Rushmore was relatively free from fissures, and the south-facing slope would both optimize the working conditions throughout the year and provide appropriate lighting to artistically emphasize viewing of the completed monument. Geologists would concur that the granite was remarkably durable and an appropriate canvas for the project.

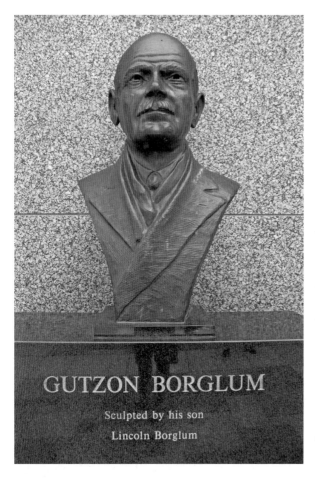

Left: A bust of Gutzon Borglum, who created Mount Rushmore National Memorial, sculpted by his son, Lincoln Borglum, is located at Mount Rushmore. *Photo by Bradley D. Saum.*

Opposite, top: Mount Rushmore, previously known to the Sioux as Six Grandfathers, stood as untouched granite in 1905, years before Gutzon Borglum's sculpture transformed it into Mount Rushmore National Memorial. *National Park Service, photographer Rise Studios.*

Opposite, bottom: After carefully observing many locations, Gutzon Borlum selected Mount Rushmore for the iconic carving of Presidents George Washington, Thomas Jefferson, Theodore Roosevelt and Abraham Lincoln. *National Park Service.*

The Mount Harney National Memorial Bill had been passed by the South Dakota state legislature on March 5, 1925, months before Borglum stood on Black Elk Peak and identified Mount Rushmore for the massive carving. The Mount Harney Memorial Association was created by South Dakota governor Carl Gunderson and would continue to operate under that name for several years.

A project of such magnitude brought skeptics, including those challenging the use of dynamite to deface the majestic mountain. Delays ensued until the spring of 1927, when President Calvin Coolidge arrived in the Black Hills to spend his summer holiday at the State Game Lodge in Custer State Park. The persistence of Senator Peter Norbeck and sculptor Borglum during that summer ultimately led President Coolidge to participate in a formal dedication of Mount Rushmore on August 10, 1927, including a pledge for

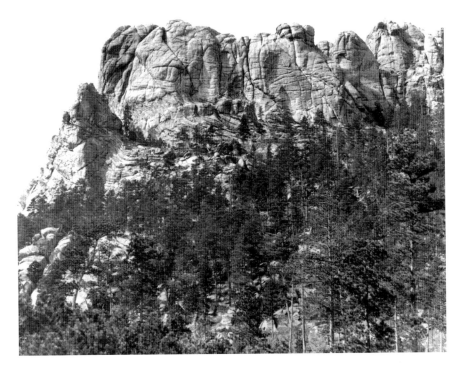

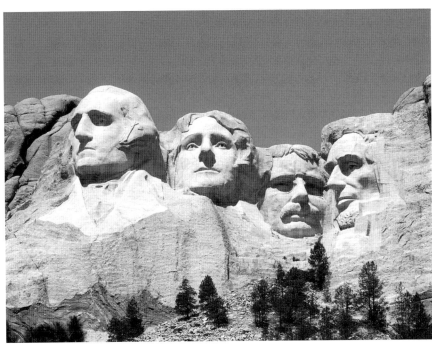

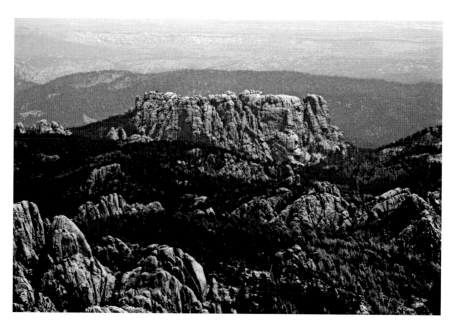

The granite outcropping known as Mount Rushmore, as observed from Black Elk Peak; the presidential rock carving is facing in the opposite direction. *Photo by Bradley D. Saum.*

The grand rock carving known today as Mount Rushmore National Memorial had humble beginnings in 1925 as the Mount Harney National Memorial Bill. *Photo by Bradley D. Saum.*

federal funding. Work began on that very day, when Borglum ceremoniously drilled six holes into the granite mountain.

Nearly two years later, in 1929, the United States Congress created the Mount Rushmore National Memorial Commission, dissolving the Mount Harney Memorial Association. The mountain carving continued until 1941, when, seven months after Borglum's death, his son, Lincoln, stopped construction of his father's vision, mainly due to the lack of funding.

The Lincoln Borglum Museum is part of Mount Rushmore National Memorial and provides interactive exhibits and a movie outlining why and how the carving took place. The Sculptor's Studio was constructed in 1939 for Gutzon Borglum and contains plaster models and tools used to fulfill his grand vision.

The parking area for the memorial is easily accessible along Highway 244, and there is only a short walk along the sidewalk to view the presidents. About 3 million people from all over the world visit the memorial each year. According to Gutzon Borglum, "The purpose of the memorial is to communicate the founding, expansion, preservation, and unification of the United States with colossal statues of Washington, Jefferson, Lincoln, and Theodore Roosevelt."

There are naturally small cracks in the granite, and Gutzon Borglum recognized the potential threat these presented. A mixture of linseed oil, white lead and granite dust was originally used to fill cracks, but this unique compound quickly dried out and became ineffective. To help keep water out, the National Park Service has removed the original mixture from the cracks and has applied a modern silicone sealant to ward off potential damage that can occur when water penetrates.

Although the iconic carving of four presidents is not visible from Black Elk Peak, the back slope of the granite standing to a height of 5,725 feet, known as Mount Rushmore, is just four unobstructed miles away and clearly within the panoramic view atop the highest peak in the Black Hills.

Burros

The rumpled spine of a burro provided transportation for those seeking the summit and a means to avoid the nearly four-mile hike on foot. Entrepreneurs introduced the burros in 1927 to transport tourists to the top of Black Elk Peak. Operating from a small building near Sylvan Lake, site of the present-day trailhead, a bevy of burros would depart with tourists precariously mounted and proceed cautiously along the unsteady trail.

Burros were also used for transporting building supplies across the rugged terrain for the construction of the roads and bridges, especially in Custer State Park. Even before the introduction of the commercial burro rides, they were used in the summer months to transport food and other supplies to the lookout tower.

As the burros that were providing trail rides aged and the trail deteriorated, the enterprise eventually stopped after several years. As they were no longer needed, the burros were simply released into Custer State Park. The burros roamed freely as they adapted to their new environment, and their population gradually grew.

Descendants of the original herd are now feral, simply meaning that although they were once domesticated and in captivity, they are essentially now wild animals. The burros found throughout North America are indigenous to arid desert plains of northeastern Africa. However, even in Africa the animal had been domesticated for thousands of years.

They were first introduced to the Western Hemisphere in 1495 in one of Christopher Columbus's supply ships. The terms *burro* and *donkey*

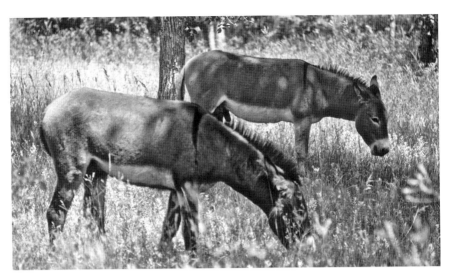

Grazing in Custer State Park, the feral burros are descendants of those that transported visitors to the summit of Black Elk Peak in the early 1900s. *Photo by Bradley D. Saum.*

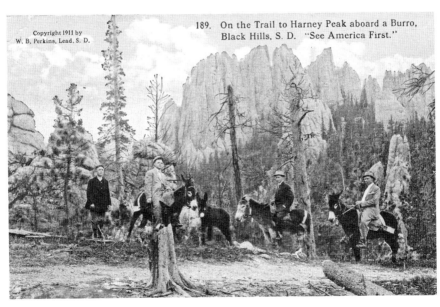

The burros used on the trail to Black Elk Peak in 1911 were later released, and the population remains wild in Custer State Park. *W.B. Perkins, L.B. Hollister.*

essentially refer to the same animal. However, *donkey* refers to the animal in captivity and domesticated, while *burro* is used for the wild, freely roaming animals.

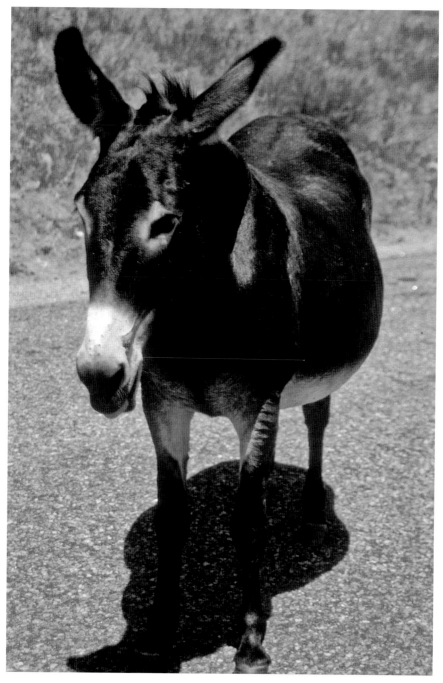

Fearlessly approaching cars traveling through Custer State Park and seeking handouts, they are commonly known as the "begging burros." *Photo by Bradley D. Saum.*

Several other parks have herds of feral burros, including Death Valley National Park and Big Bend Ranch State Park, both located in Texas. The burro populations are carefully monitored, as they can compete with local wildlife for food, water and space.

Commonly known as the begging burros in Custer State Park, they often walk on the roads, blocking traffic and approaching tourists along the way seeking handouts. There are about forty to fifty of the burros in Custer State Park. The activity of sharing a snack or your lunch with the burros is discouraged, as they are wild animals, although they present little danger. Junk foods can make the animals sick, as they predominantly graze the grasslands as a natural diet.

Regardless of how friendly and harmless the burros may be, the same does not apply to other wildlife in Custer State Park, or anywhere. The buffalo are truly wild and are dangerous, even if they appear to be grazing and unconcerned with their surroundings. Wild animals should be respected and viewed from a distance and absolutely never approached.

An advertisement for the donkey rides to Harney Peak, as it was then known, appeared in the *Columbus Journal*, of Columbus, Nebraska, on Wednesday, August 23, 1899:

The Famous Black Hills Summer Resort. Elevation 6,300 feet. Dry Air. Hot weather unknown. Mountain scenery unsurpassed. Black Elk Peak by donkeys. Boating on the Lake. Home is new and modern. Send for Souvenir Views. Sylvan Lake Hotel, Custer, S.D.

Four Wheels

The first vehicle to make it to the summit of Black Elk Peak was a modified Model A Ford that had been dramatically trimmed down to just thirty inches wide. Hap McCarty purchased the narrow, odd-looking version of the Model A to haul supplies to the concessions that he operated at the top of Black Elk Peak during the early 1950s.

To accommodate bringing some friends to the summit, McCarty also acquired a Jeep. The requests for an easier trek to the top of Black Elk Peak became ever more frequent. In 1952, the entrepreneur in McCarty took advantage of the situation, and he started offering rides on the Jeep to Black Elk Peak.

An early brochure advertised that the Jeep ride was safe but rugged. It also described the shake, rattle and roll involved in the trip to the summit. The Jeeps would traverse a narrow dirt trail, navigate a series of hairpin turns and ascend a 47 percent grade to reach the high point of the Black Hills—actually, a point just below the actual summit. Even with a Jeep the final ascent was accomplished on foot.

A concession building was located near Sylvan Lake and served as the hub for the visitors awaiting the easy ascent on four wheels. It was a thriving seasonal business that continued for many years. The trails gradually deteriorated from the heavy use, and the resulting erosion was having a negative impact on the environment. The rides were eventually discontinued in 1968.

Byron Hazeltine was the U.S. Forest Service ranger stationed at Black Elk Peak on watch for forest fires during the time the motorized rides were

bringing tourists up the trail. Hazeltine served with the forest service at Black Elk Peak for more than fifteen years.

The convenience could not be avoided, and the Jeeps were also used occasionally to transport the fire lookouts and supplies to the stone tower at the summit. Vehicle access prevented hiking over three miles to the peak and made easy transport for food and other basics.

The area surrounding Black Elk Peak is now a designated wilderness area. Motorized vehicles are prohibited, so the only way to access the summit is now on foot or by horseback.

Hitch Rail

Reminiscent of the early exploration of the Black Hills by Native Americans, as well as later with Europeans such as Lieutenant General Gouverneur K. Warren and General George Armstrong Custer, Black Elk Peak remains accessible by horseback. As motorized vehicles and even bicycles are not permitted in the designated wilderness area around Black Elk Peak, the trails make for excellent riding.

Horses and mules are allowed on the trails around Harney Peak. Riding to the summit now includes a system of well-maintained trails. However, the challenge that General Custer faced remains. The actual summit of Black Elk Peak is sheer granite protruding from the ground below and is not accessible by horseback.

The final climb to the summit utilizes the luxury of stairs, making the peak relatively easy to reach on foot. For those dismounting for the final push to the high granite, a hitch rail has been installed for stock. A hitch rail, sometimes referred to as a tie rail or tethering rail, simply provides a location to secure a horse or mule while the rider briefly steps away. The hitch rail just below the summit of Black Elk Peak is constructed of wood timbers and rope. The rail is clearly marked with "Stock Only" signs and located just below the actual peak. Stone stairs accompany the hitch rail, providing a comfortable and accessible location to break and finish the climb on foot.

Opposite, bottom: Stone steps provide easy access to the level staging area designated for horses, as the final push to the summit is only accessible by walking. *Photo by Bradley D. Saum.*

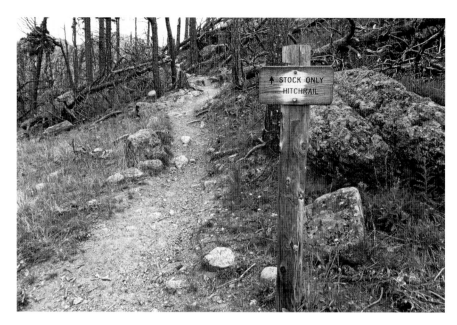

Along the trail to Black Elk Peak, signs designate the path to follow on horseback to reach the hitch rail. *Photo by Bradley D. Saum.*

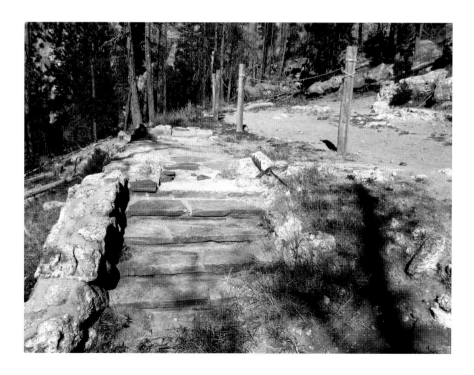

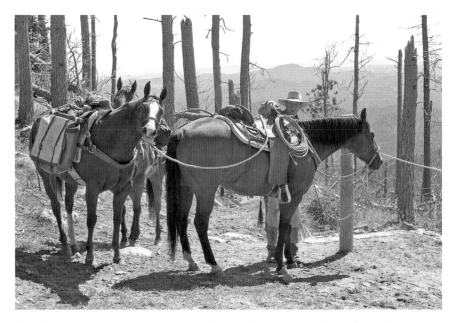

The hitch rail located just below the summit provides a level place for mules and horses to rest while the riders dismount and climb to the summit. *Photo by Beth Doten, Black Hills National Forest.*

There is no camping directly around Black Elk Peak, so the use of the hitch rail is designed for brief periods, allowing the riders to enjoy the panoramic view from the high point. The hitch rail area is shaded and also provides stock a level resting place.

Camping is allowed anywhere in the Black Elk Wilderness except within a quarter mile of the summit. There are limits on the size of groups to minimize environmental impact. In an interesting method of counting, groups are limited to twenty-five beating hearts, which includes stock, pets and hikers. The smaller the group, the less potential damage to the natural area, and therefore even smaller-size groups are recommended.

There are designated camps for overnighting with horses in the Black Hills National Forest. Willow Creek Horse Camp provides a great launching pad for the ride to Black Elk Peak. The camp is located where Willow Creek and Palmer Creek converge in the Black Elk Wilderness Area to the north of Black Elk Peak. Tie-up areas for horses are provided, but there are no corrals. Another alternative, but with less direct access to the summit, is Iron Creek Horse Camp. It is to the southeast of Black Elk Peak and offers paddocks. This camp provides access to the Centennial Trail for riding.

The Willow Creek Trail that begins on Highway 244 near Palmer Gulch and the Mount Rushmore KOA is a popular alternative to Trail Number 9 from Sylvan Lake for horses. The Willow Creek Trail is longer at five miles each way but offers incredible vistas, small creek crossings and occasionally some technical picking through fallen trees.

When horses are used to traverse the Black Elk Wilderness, it is important to remember that all feed and hay must be certified as weed-free. This helps protect the natural state of the area and prevent the introduction of foreign or domestic vegetation. Riders should always be cautious of falling trees and branches, as well as trees that have fallen across the trail.

The hitch rail just below Black Elk Peak is routinely used by the Back Country Horsemen of South Dakota as they contribute their time and effort to maintain the trails, helping keep them passable and safe. This is especially challenging with all the timber that has fallen as a result of the mountain pine beetle. The Back Country Horsemen also assist with transporting building materials to the summit of Black Elk Peak for repair to the fire lookout tower.

The journey to reach Black Elk Peak on a good saddle horse or mule culminates with the view from the high point destination. There are numerous stables, camps and ranches throughout the Black Hills that can provide necessary accommodations and provisions for both the horse and the rider.

LOOKOUTS

Reaching the summit by horseback, Rufus J. Pilcher unpacked his meager gear just below the high point of Black Elk Peak and spent the night in a tent. The next morning, Pilcher placed a wood crate at the summit as the sun was rising, scanned the forest below and actually spotted smoke rising from the trees. It was the first day for Black Elk Peak to be used as a fire lookout and the first fire reported from the summit. The timing was impeccable and rewarding.

Equipped with nothing more than a compass, binoculars and an alidade, Pilcher served as the first fire lookout stationed at Black Elk Peak in 1911. It was the start of what would be a fifty-six-year tradition of spotting fires from the high point. There would be many changes and improvements during those nearly six decades of scanning the forests below for smoke. Multiple structures would eventually be constructed, and many different people would serve as lookout at the highest peak in the Black Hills.

Three early spring forest fires in 1916 resulted in the need for staffing the Black Elk Peak lookout station in April, much earlier than the typical start of the summer fire season. By the time August rolled around that summer, six hundred visitors had been logged at the lookout, each making the hike to the remote high point. Black Elk Peak was fulfilling the dual purposes of monitoring for fires and also serving as a visitor center.

In the spring of 1919, a fierce snowstorm stranded Earl H. Emmons and his wife at the summit for several weeks. Earl, who was formerly an army lieutenant, and his wife, Hazel, had served as lookouts at Black Elk Peak the

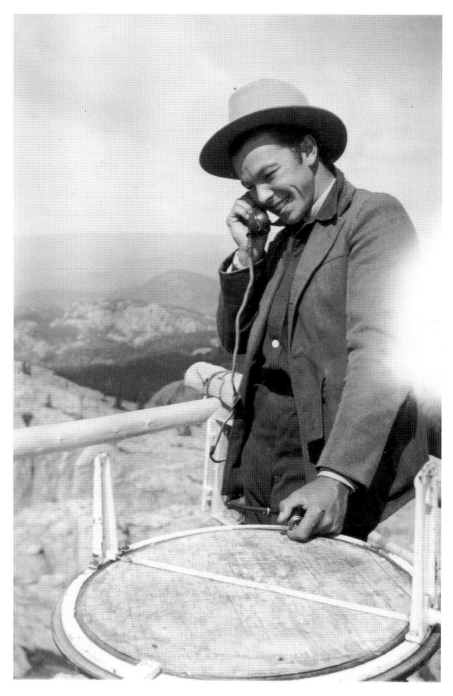

The first lookout stationed at the new stone fire tower, Howard Culver, holds the phone while looking at the fire finder on August 31, 1938, at Black Elk Peak. *U.S. Forest Service.*

year prior to the enclosed structure being built and lived in a small cabin just below the summit.

A rescue party attempted to reach Emmons but was forced to turn around when faced with the fifteen- to twenty-foot snow drifts. Telephone communication was eventually established, and Emmons was actually found to be enjoying the experience and had sufficient firewood and food to remain comfortable. Emmons continued to serve as the lookout through the end of 1921. That first twelve-foot-square fire lookout tower built in 1920 was staffed by Emmons and his wife, Hazel.

Starting in 1922, Mr. and Mrs. Paul J. Beard staffed the lookout station during the summer months. The U.S. Forest Service did not have many women working in the field during the early 1920s, but Mrs. Beard at the summit of Black Elk Peak was one exception. She would work on the remote high point during the summer and then attend college in the winter in Ames, Iowa.

During the summer of 1924, the lookouts spotted thirty-five fires and logged 7,650 visitors, maintaining the dual role of fire lookout and visitor center for the ever-increasing number of people making the trek. Howard Culver and his wife were the first to staff the relatively luxurious stone structure that extended thirty-five feet above the summit. The second lookout in the massive stone building was Byron Hazeltine, who started in 1942. Serving as a lookout meant spending the majority of the summer living and working atop Black Elk Peak, and the accommodations of the stone lookout tower certainly made the summers more comfortable.

By 1954, there were sixteen fire lookout towers throughout the Black Hills National Forest monitoring the region for wild fires. At the top of Black Elk Peak was Kathy Clark, a forestry student at the Iowa State Agricultural College, staffing the lookout by herself for several summers. Clark would typically work eight to ten days at a time and then come down the trail for a day off. During the summers that Clark staffed the lookout, there were about two hundred fires per summer, making for a busy time during and immediately after lightning storms, when multiple fires might be started.

Staffed by the U.S. Forest Service until 1965, the South Dakota Department of Game, Fish and Parks provided lookouts for the following two years. Then, after 1967, Black Elk Peak was no longer officially staffed. Airplanes, helicopters and other strategically placed fire lookout towers provided sufficient fire detection coverage of the region and eliminated the need for Black Elk Peak to be staffed.

TOWERS

The process of watching for fires from a high observation point in the United States began as early as 1876, when the first fire lookout tower was built by the Southern Pacific Railroad on Red Mountain near Donner Summit to watch for train fires.

On Black Elk Peak, a simple wood crate served as the first lookout in 1911 and started the tradition of spotting wildfires in western South Dakota from Black Elk Peak. A map of the region was mounted with thumbtacks to the wood. Black Elk Peak was at the center of the map, and the compass points and degrees were manually marked around the map. With this map and an alidade, a fairly precise location of a fire could be determined, especially if the lookout had a pair of binoculars and was also familiar with the surrounding landscape.

A telephone line was installed the following year in 1912 from nearby Hill City running all the way to the summit of Black Elk Peak. This provided the

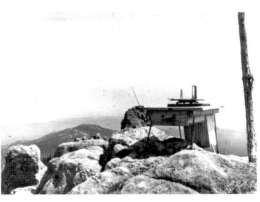

Beginning in 1911, a simple table was perched on the summit and used to watch for forest fires in the Black Hills. *U.S. Forest Service.*

fire lookout with immediate communication to the Harney National Forest headquarters in Custer. Forest Ranger Poe made this possible and directed the crew digging all the post holes to hold the telephone line.

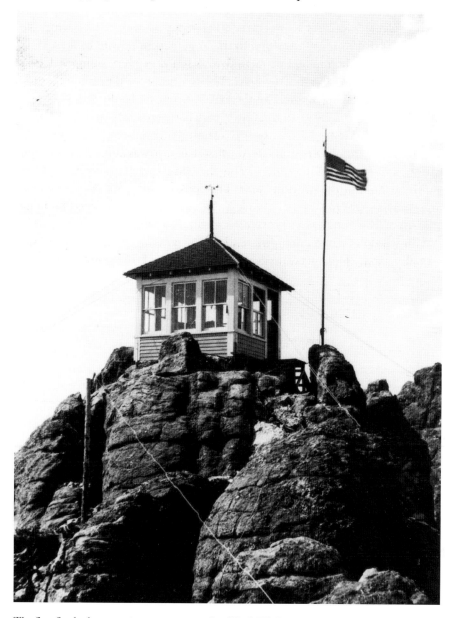

The first fire lookout tower was constructed at Black Elk Peak in 1920, and the adjacent American flag was lifted to the highest point in South Dakota. *U.S. Forest Service.*

In 1915, there were two fire lookout stations to protect what was then called the Harney Forest. There was one on Black Elk Peak, which was the highest point at 7,242 feet, and also one on Bear Mountain, a prominent peak at 7,166 feet standing about ten miles to the west.

The original wood crate was very soon replaced with a table, and the legs of the table were later secured to the granite summit with cement. This continued to be the method of identifying forest fires every summer. It was not until eight years later that the first cabin was constructed near the summit, providing simple living quarters for the lookouts. The twelve-foot-square cabin was constructed in May 1919 to provide very basic comforts, and the lookout point was accessible by a ladder leaned against the granite.

With three windows on each side, the first structure was built on the summit in 1920 and measured the same size as the living quarters constructed just below the summit the previous year. This lookout station was a significant improvement, not just as a structure but also as the first enclosed building with a roof and windows to protect the lookout from the elements.

With windows surrounding the entire new structure built on Black Elk Peak, these early lookouts were described as glass houses. Heavy steel cables

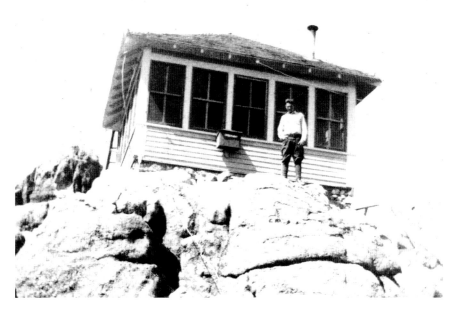

George Voronyak, a pilot from Little Falls, Minnesota, who flew with Charles Lindbergh, visited Black Elk Peak Fire Lookout tower in June 1928. *Patsy Straka.*

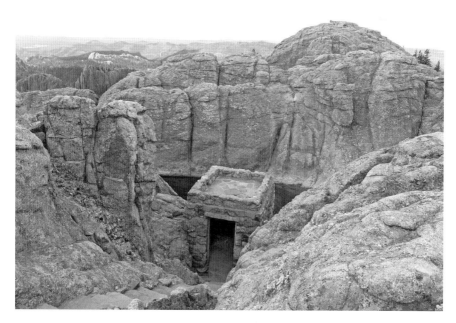

The stone structure adjacent to the retention pond was built to house a generator and pump to provide running water to the living quarters. *Photo by Bradley D. Saum.*

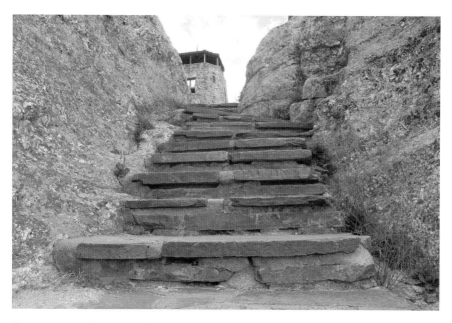

Stone steps were incorporated into the granite crevices to allow for easier access to the pump house and retention pond. *Photo by Bradley D. Saum.*

secured the structures to the granite summit at various angles. The tower was enlarged the next year to sixteen feet square, with two additional windows on each side.

Perched on the peak, the fire tower was still accessible by a twenty-foot ladder to scale the steep granite and reach the summit of Black Elk Peak. Although the enclosed structures provided basic comforts, wood was needed to provide heat, especially in the spring and fall. The firewood was carried a few pieces at a time up the ladder.

The fire lookout structure remained atop Black Elk Peak for eighteen years until 1938, when it was removed to make way for the grand stone lookout tower that currently caps the summit.

NEW DEAL

The aesthetically pleasing and architecturally significant fire lookout tower nestled on the granite summit of Black Elk Peak was a beneficiary of the Great Depression. During his first one hundred days in office, President Franklin Roosevelt's "New Deal" created the Civilian Conservation Corps (CCC), engaging the nation's unemployed young men in natural resource management.

The liberal social programs of the New Deal were designed to provide employment, otherwise largely unavailable, and help reverse the economic downturn of the Great Depression. About 500,000 men were enrolled in 2,600 camps located across the country at the peak of activity in 1935, and across several years, more than 3 million people participated in the Civilian Conservation Corps. This made the federal government the largest employer in the country.

Among the flurry of ambitious projects undertaken by the Civilian Conservation Corps, 3 billion trees were planted, hiking trails were constructed, lodges were built and campgrounds were added to state and national parks. Miles and miles of roadway were also built by the CCC, typically in more remote areas. Additionally, more than 3,470 fire lookout towers were erected to protect forested land.

One of those fire lookout towers was built by CCC Camp F-23 Doran in the Black Hills from 1935 to 1938. Traversing nearly four miles of trail, Black Elk Peak was accessible only by man and mule. The endeavor included manually hauling all the construction materials to the peak, including more

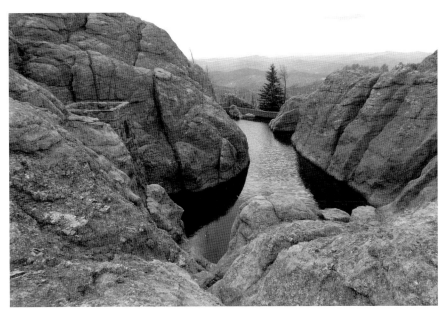

Above: A dam was constructed to retain water, and the accompanying pump house provided water to the remote fire lookout tower. *Photo by Bradley D. Saum.*

Right: A steel stairway provided access for the lookouts between the sleeping quarters and upper lookout area of the tower, which provided a commanding view of the hills. *Photo by Bradley D. Saum.*

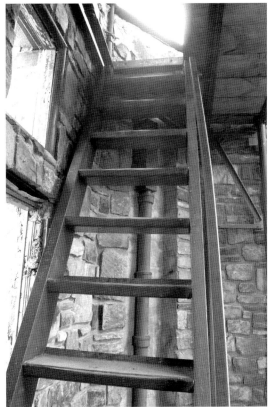

than 7,500 rocks plucked from French Creek and the surrounding landscape. That was a considerable task alone, as the makeshift carts created to be pulled by a horse could only transport about 20 rocks per trip.

Transporting other building materials to the peak proved to be equally challenging. Carts were designed by cutting fifty-five gallon drums in half to lug the 1,328 bags of cement along the trail. The cement, as well as tons of sand needed for mixing, was pulled by horses in a line of ten as they made their way to the summit. Several logs more than 20 feet in length also had to be maneuvered to the construction site at 7,242 feet in elevation and well over three miles from the trailhead.

The vast amount of building materials needed for a project of such magnitude included hundreds of feet of steel cable, kegs of nails, reinforced steel, angle iron, copper and steel wire, among many other items. Achieving the goal of transporting supplies to the summit was actually just the beginning, as all of these materials needed to be formed into a stone fire tower that would rise out of the granite peak.

Supervisor E.A. Snow was responsible for oversight of the construction of the stone tower. Climbing rope ladders to reach the peak, the work was precariously adjacent to the eighty-foot cliff of granite. Large nets were

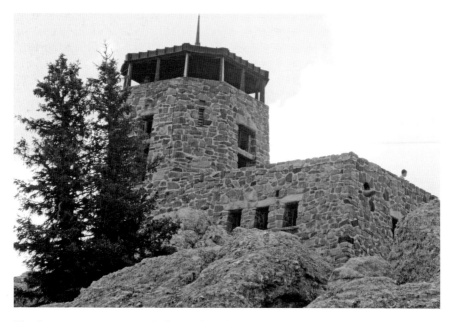

The fire tower was constructed of stone from French Creek in nearby Custer State Park and had to be manually hauled to the summit. *Photo by Bradley D. Saum.*

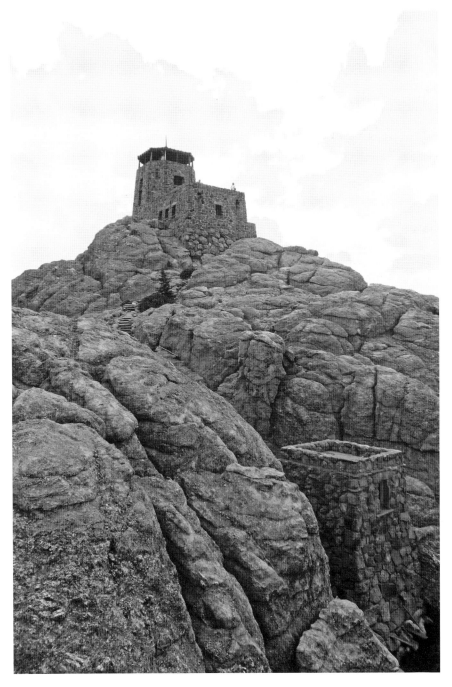

Left: The fire tower is positioned at the crest of Black Elk Peak, providing a commanding view of the forested land below. *Photo by Bradley D. Saum*.

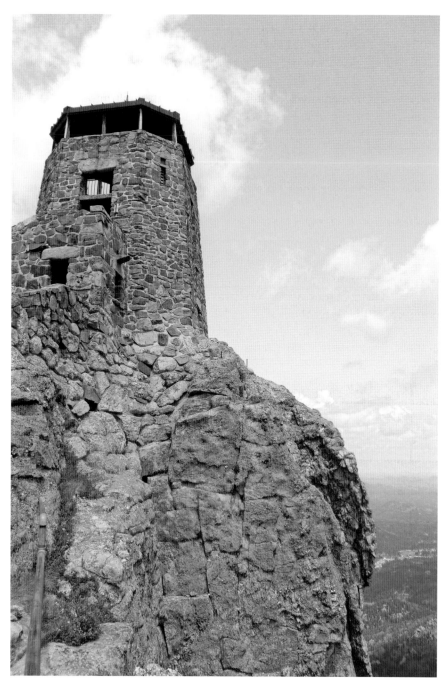

The stone lookout tower was designed specifically as an extension of Black Elk Peak and built by the Civilian Conservation Corps. *Photo by Bradley D. Saum.*

spread about to soften the fall should someone lose their footing on the scaffolding, but work proceeded with no accidents.

Architecturally designed as a natural extension of the summit, a complementary pump house and dam were also constructed to provide water to the resident lookout atop Black Elk Peak. Built into a gap in the granite, the pump house supplied water from the five-thousand-gallon reservoir created by a dam. A stone staircase was implanted into the granite for easy access to the lookout protruding thirty-five feet above the summit.

With living quarters below, a terrace to absorb the view and a glass enclosed tower above, the Harney Peak Lookout Tower, as it was then called, made for a comfortable, albeit remote residence. The amenities included running water, flush toilets, shower, central heating system and electricity.

Several years after construction was completed, an Electrolux refrigerator was manually lugged to the summit in 1942. It took twenty-one men three days to accomplish the task.

The Civilian Conservation Corps was arguably one of the most successful programs of the Great Depression and definitely one that left a lasting impact on the landscape and future of natural resource management. The CCC was never established as a permanent agency; rather, Congress provided

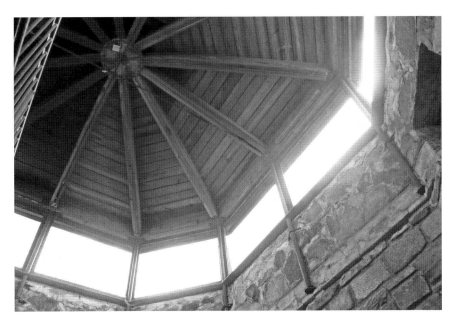

The windows at the top of the fire tower provide an unobstructed view of the Black Hills, useful in watching out for rising smoke indicating a fire. *Photo by Bradley D. Saum.*

George Roe in 1938, an eighteen-year-old CCC crew member, standing in front of his bunkhouse at CCC Camp Doran, which was just below Stockade Lake. *Black Hills National Forest.*

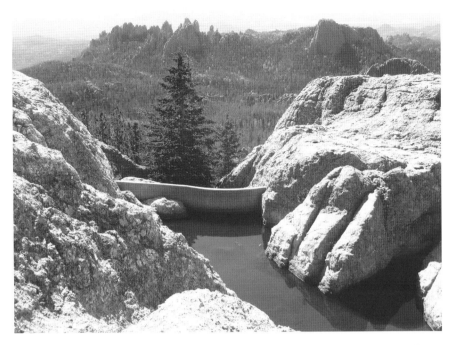

A cement dam was constructed between granite crevices to retain water for use in the living quarters of the fire lookout tower. *Photo by Bradley D. Saum.*

funding to maintain it. Eventually, the interest in the Civilian Conservation Corps waned, and with the bombing of Pearl Harbor, the war effort took priority, signaling the end of an era that had left a permanent mark that remains readily visible in parks all across the country.

SMOKE

Perched on the peak with a view surpassed only by a gliding hawk, the watchful eye of the lookout searched endlessly for nothing more than a small stream of smoke rising gently from the forest below. A scurry of activity would follow as the location was pinpointed and dispatches were sent to attack.

The impact of the Great Fire of 1910 was devastating, and the 3 million acres burned in Montana, Idaho and Washington forced a new view on wildfire management. Fire lookout towers were helpful in detection and ensuring a fast response to start suppression, and they gradually became a critical element in managing forests. Located in areas that were sparsely populated and before the influx of immediate communication, the fire lookout was critical to preserving the forest. Heavily populated areas can rely more on the general population reporting smoke and fires, but this was not the case at the turn of the century in the sparsely inhabited rural areas of western South Dakota.

The Civilian Conservation Corps built many fire towers in the 1930s, and for the next twenty to thirty years, they were the primary detection system for wildfires. With the exception of Kansas, every state has had at least one fire lookout tower. The fire tower at the highest elevation in the United States is on Fairview Peak in Colorado, and the lowest lookout is at two feet above sea level on Pine Island in Florida.

The earliest lookouts were simply high points with unobstructed views of the surrounding forest. Gradually, tents and cabins were added for shelter, and some of the local trees would be cut down to provide a 360-degree view.

If high points were not readily available, then towers were constructed to provide the commanding view. The tallest fire lookout is Woodworth Tower, standing at 175 feet off the ground in Alexandria, Louisiana.

In 1940, there were about eight hundred staffed fire lookouts in the country watching over the forests to detect any sign of fire. The design of the lookouts needed to be sufficiently strong to ensure the harsh weather conditions at these peaks that provided the best views. Eventually, the towers provided basic needs and some level of comfort for the lookouts.

The eyes were on the highest peak in the Black Hills to watch for the telltale sign that the forest was being invaded and the assailant was fire. The fire finder alidade, maps and radio were essential tools for the spotter. Although there were slight variations on the design, essentially the alidade consisted of a metal piece used to look through to identify the location of the smoke. The alidade sighting mechanism rotated over the top of a fixed map marked with compass degrees along the edge.

The swirl of rising smoke was spotted through the panoramic glass windows at the top of the tower. Equipped with the fire finder, the spotter would swivel it to align with the smoke and take a reading in compass degrees and draw the corresponding line on a map.

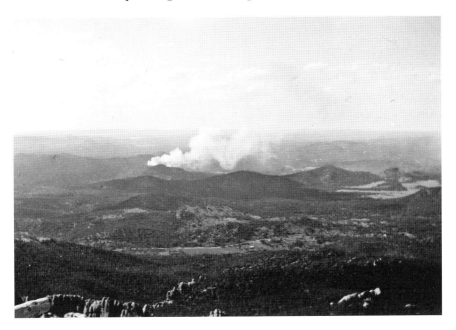

The rising smoke in the distance clearly indicates a 1938 forest fire in the Black Hills, as viewed from Black Elk Peak. *U.S. Forest Service.*

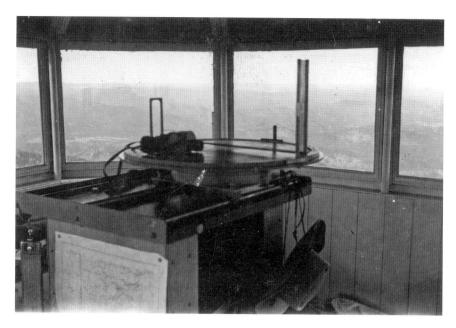

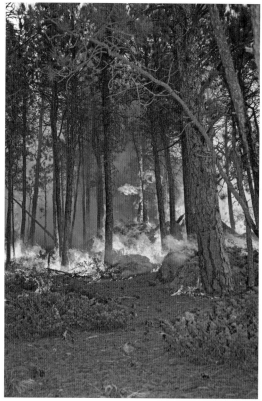

Above: A pair of binoculars rests on top of an Osborne Fire Finder, with the surrounding Black Hills framed by the windows of the fire lookout tower on August 9, 1958. *U.S. Forest Service*.

Left: Dense underbrush can provide fuel for a wildland fire to spread quickly, which necessitates the need for early detection. *Photo by Beth Steinhauer, Black Hills National Forest.*

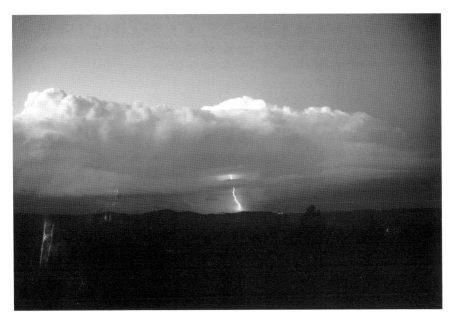

Thunderstorms bring the risk of forest fires in the form of lightning strikes in the Black Hills near Black Elk Peak. *Photo by Bradley D. Saum.*

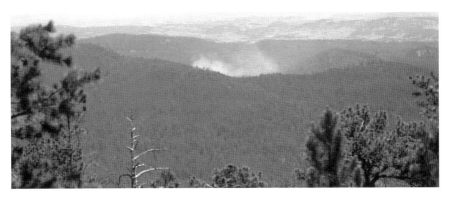

Smoke rising over a hill in the distance from Black Elk Peak indicates a forest fire burning. Early detection can limit the extent of the damage. *Photo by Bradley D. Saum.*

William Bushnell Osborne Jr. invented a fire finder while with the U.S. Forest Service in Oregon in 1910. Sighting mechanisms were attached to a rotating steel disc. The exact geographic location of a forest fire could be identified by the lookout. Although the original device has since been modified and improved with technology, the Osborne Fire Finder appeared in many lookout towers for years as standard equipment.

An Osborne Fire Finder was used at Black Elk Peak, as evidenced in a 1958 photograph taken there. There are two sighting apertures on either side of the circular surface that contains a map. The rising smoke is aligned, providing a line on the map where the fire is located. Coordination with another fire tower would identify the precise location where the two lines overlapped. Alternatively, local landmarks and distinctive features could also be used to help pinpoint the exact location.

To further identify the exact location, a spotter in another tower would be doing the same, communicating their compass reading via telephone or radio. The two readings were converted to lines drawn on a map, and the intersection identified the location of the fire. With the precise location known, firefighters would be dispatched to respond and extinguish the fire.

FRIEND OF CRAZY HORSE

A modest bronze memorial at the highest point in the Black Hills marks the final resting place of a distinguished physician, topographer, mayor, Indian agent, college president, husband and father. Sixty-five years after making the first recorded ascent of Black Elk Peak, the ashes of Dr. Valentine T. McGillycuddy were entombed at the summit.

The fascinating and exceptional life of McGillycuddy is uniquely intertwined with the early settlement of the Dakota Territory. Among other things, while filling a multitude of professions, he was quite the controversial character on the frontier.

Born in 1849, he was a doctor at the Wayne County Insane Asylum in Detroit and nearly an alcoholic before he changed careers and became skilled as a topographical engineer and cartographer, all before he was twenty years old. He then worked in Chicago as a surveyor after the great fire in 1871.

He spent the summer of 1875 mapping the Black Hills on an expedition led by geologists Walter P. Jenney and Henry Newton, commonly referred to as the Newton-Jenney Expedition. Following on the heels of General Custer's foray into the Black Hills the previous year, the Newton-Jenney Expedition was primarily focused on understanding the quantity of gold deposits in the region. Mining for gold was not allowed at this time in the Black Hills, as the area was in the Lakota Territory.

McGillycuddy's scientific exploration of the Black Hills culminated with the climb to the summit of Black Elk Peak. Although the peak had been

climbed many times before by the Native Americans, this was the first recorded climb to the summit by a European.

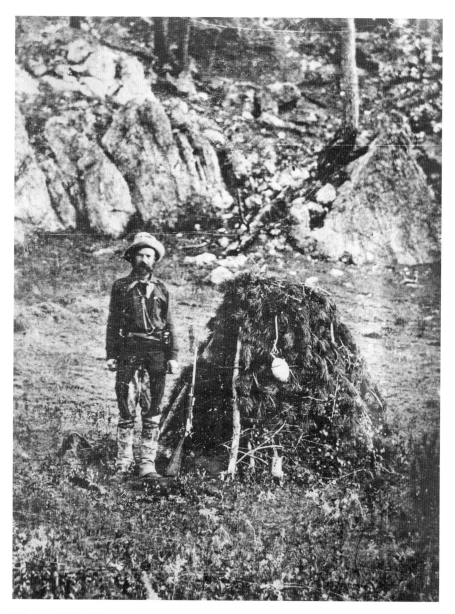

Valentine T. McGillycuddy stands by his temporary sleeping quarters along with his rifle during an 1876 expedition to the Black Hills in the Dakota Territory. *U.S. National Archives and Records Administration.*

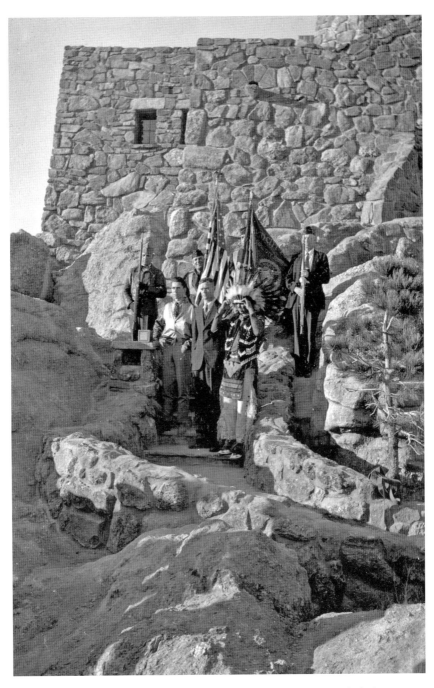

The ashes of Dr. Valentine T. McGillycuddy were entombed at the summit during a ceremony on October 16, 1940, with several nephews of McGillycuddy, Chief Lone Star and an American Legion color guard present. *Photo by E.A. Snow, Black Hills National Forest.*

McGillycuddy crossed paths with a wide range of notable figures. He met with Sitting Bull while surveying the boundary between the United States and Canada, discussed the perils of traveling the frontier with Buffalo Bill Cody and Wild Bill Hickok, danced with Calamity Jane and served with General George Crook as his field surgeon.

He gradually befriended Chief Crazy Horse and even cared for his wife, Black Shawl Woman, who suffered from tuberculosis. When Crazy Horse was stabbed on September 5, 1877, at Camp Robinson, it was McGillycuddy who cared for him throughout the night, administering morphine to ease his suffering. The Sioux would forever know him as "Tasunka Witko Kola" (Crazy Horse's friend).

Genuine efforts to carve a sustainable relationship between the European immigrants and the Native Americans earned McGillycuddy a positive reputation among the Sioux. As the first Indian agent at Pine Ridge, the thirty-year-old McGillycuddy served for seven years, from 1879 to 1886, presumably to improve life on the reservation. His direct responsibility for building a school, fighting corruption and organizing a law enforcement force garnered respect from the Sioux at Pine Ridge.

However, his strict tactics and stubborn approach were frequently questioned and challenged, both by the government and by Chief Red Cloud. Although clearly a strained relationship, there appears to have been a mutual respect at some level between McGillycuddy and Red Cloud. "That is Wasicu Wakan (White Holy Man)," Red Cloud would later state, adding that "he was a young man with an old man's head on his shoulders."

After being removed by politicians from Pine Ridge Reservation, McGillycuddy and his wife moved to nearby Rapid City, and he was soon elected mayor. Among his other diverse accomplishments in the Dakota Territory, after serving as mayor of Rapid City, he would serve as president of the South Dakota School of Mines and Technology, president of a regional bank and surgeon general of South Dakota. In 1890, he was elected to the state constitutional convention.

At the age of ninety, McGillycuddy died on June 7, 1939. Even upon his death, he had yet another unique accomplishment, being the first and only person buried at the summit of Black Elk Peak. His ashes were entombed in

Opposite, top: Crazy Horse Memorial is being carved in the Black Hills as a tribute to Native Americans; it is the world's largest mountain carving in progress. *Photo by Bradley D. Saum.*

Opposite, bottom: Interment services for Dr. Valentine McGillycuddy were held on October 16, 1940, on Black Elk Peak. *Forest History Society, Durham, North Carolina.*

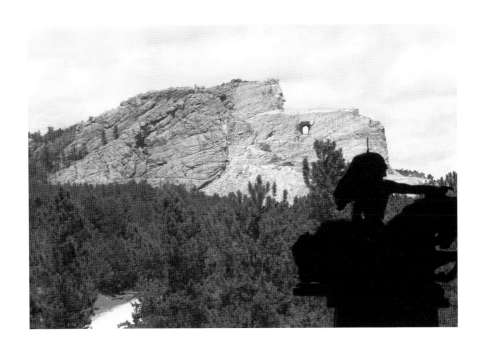

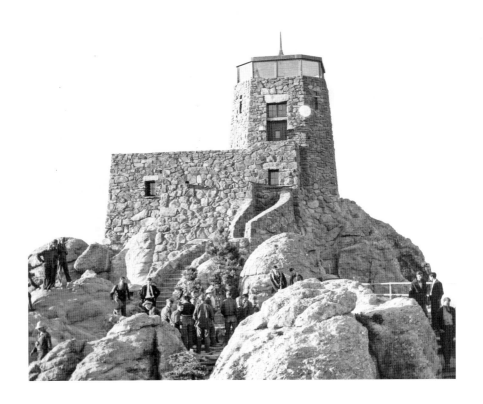

A plaque memorializing McGillycuddy is located at the base of the stairs leading to the lookout tower at Black Elk Peak. *Photo by Bradley D. Saum.*

a small box during a formal ceremony at the highest point in the Black Hills, and a modest plaque memorializes the White Holy Man who was known as the Friend of Crazy Horse.

McGillycuddy was undoubtedly one of the most fascinating and controversial characters in the Dakota Territory. Often viewed inquisitively by hikers relieved to reach the summit, the bronze plaque mounted on the stairway of the stone fire tower marking the crypt that contains his remains reads, "Valentine T. McGillycuddy—Wasicu Wakan 1849–1939."

OFFICIALLY HISTORIC

Formally entered into the National Register of Historic Places on March 10, 1983, it is recorded as the Harney Peak Lookout Tower, Dam, Pumphouse and Stairway. Harney Lookout is also listed in the National Historic Lookout Register, which is often a precursor to being listed in the National Register of Historic Places.

The nomination form was compiled by Terrell W. Reetz, a landscape management group leader with the U.S. Forest Service in Custer, South Dakota. In his endorsement of the nomination, Paul V. Miller, a professional archaeologist, described Harney Peak Lookout as "architecturally unique and perhaps a curiosity in both its form and setting as well as the rigor involved in its construction."

The National Historic Preservation Act of 1966 authorized the creation of a list of the nation's historic sites that should be preserved and established the process for designating locations. The National Park Service maintains the National Register of Historic Places list with the intent of helping to protect the historic sites. There are currently more than ninety thousand properties listed. Federal Regulation 36 CFR 60 authorizes the National Register of Historical Places.

Typically, properties need to be more than fifty years old to be considered for listing and should remain visually similar to their original construction. There must also be some level of significance, whether in its association with historical events, intermingled in the lives of historical figures or present an architectural or engineering achievement.

The listing is largely symbolic in that it does not guarantee protection of the designated site and does not garner any immediate funding. A National Register of Historic Places listing enables the location to be considered for federally funded preservation projects, as well as grants when they are available.

The primary criteria for the Harney Peak Lookout listing is the noteworthy architecture and engineering, which correspond to the intricate design to incorporate the tower as an extension of the granite peak and the complexities associated with the construction of the structure. Three areas of significance are noted and include conservation, entertainment/recreation and architecture. The period of significance recorded is 1925 to 1949.

The conservation significance was documented through the ability to detect fires, which was critical for the protection of property as well as timber resources. From a recreational standpoint, it notes the thousands of visitors who make the trek to the summit not merely to see the lookout tower but primarily because of the view from the structure of the surrounding ponderosa pine forests. The architecture of the lookout tower was also mentioned in the nomination form, noting that it is unique and does not follow any standard building plans. The tower was designed specifically for the landscape at Black Elk Peak and extends above the granite as a natural extension.

The nomination form for the Harney Peak Lookout acknowledged the critical role of the Civilian Conservation Corps in the construction of the structure. The submission indicates that the Harney Peak Lookout "is a priceless example of Civilian Conservation Corps workmanship in the Black Hills."

The man-made structures delicately perched on the granite summit of Black Elk Peak are included in the Harney Peak Lookout listing in the National Register of Historic Places. The boundary was described as "all of Harney Peak above the 7,160 foot contour." The listing includes all structures above that point. Therefore, in addition to the fire tower lookout structure, the stone staircase, the McGillycuddy crypt, the pump house and the dam were all included in the designation.

Referencing three distinct structures—the lookout tower with stairway, the pump house and the dam—the site was officially recognized as worthy of preservation. There is a plaque at the summit recognizing that the structures built on Black Elk Peak by the Civilian Conservation Corps are listed in the National Register of Historic Places.

A History

It is the role of every federal agency to identify, evaluate and protect historic properties. As the Harney Peak Lookout Tower, Dam, Pumphouse and Stairway reside under the management of the U.S. Forest Service, there is a responsibility for historic preservation. The U.S. Forest Service has a documented preservation plan, and efforts have gradually been underway since 2012 to preserve the current state and prevent future damage.

TRIANGULATION STATION

Although the precise coordinates and elevations are well documented, finding the three little bronze markers embedded in the granite results in a scavenger hunt, requiring a somewhat treacherous scramble around the summit.

A cornerstone of making maps since 1879, benchmarks, also referred to as triangulation points or stations, are used by surveyors because their exact position is a known and serves as a permanent reference point. Now numbering near 1 million, these benchmarks are placed throughout the United States, including the three located on Black Elk Peak that were positioned in 1950.

Triangulation stations exist in various forms all over the world to serve as fixed surveying points. Typically, they were installed by governments and have known coordinates and elevation. The stations are actually no longer needed for routine surveying, having been replaced with modern technology.

Less than four inches in diameter, the small bronze plaques are flush with the surrounding granite at Black Elk Peak. There is a primary benchmark atop Harney, and per standard practice, the U.S. Coast and Geodetic Survey includes two additional markers of similar appearance nearby.

Primary benchmarks are identified with two capital letters and four numbers, creating the permanent identifier, or PID. The station name and year positioned are stamped on the plaque. OT0810 Harney, OT0812 Harney Peak Lookout Tower and OT0813 Harney Peak Airway Beacon are on Black Elk Peak.

Each benchmark has a Geodetic Data Sheet logging the longitude, latitude and elevation, managed by the U.S. Coast and Geodetic Survey, which now operates under the National Oceanic and Atmospheric Administration (NOAA).

Typically, a primary marker is placed near the highest point of the peak, and two other markers are positioned within fifty feet of the primary marker. The two supporting markers are stamped with an arrow pointing to the primary marker. Serving as reference points, and accordingly stamped RM1 and RM2, they provide a means to locate the primary marker should it be not visible, covered with fallen rock, eroded soil or not present at all.

The primary benchmark atop Black Elk Peak, identified as 0T0810, is positioned at 7,242 feet. It was located 7 feet north of the northwest leg of the airway beacon and stamped with the station name Harney, as well as the year 1950.

Reference mark number one was positioned twenty feet northeast of the airway beacon and stamped Harney No. 1 1950. The second reference mark was placed twenty-five feet northwest of the airway beacon and stamped Harney No. 2 1950.

The supporting benchmarks have an azimuth mark, or arrow, inscribed that points in the direction of the primary station. This line of reference

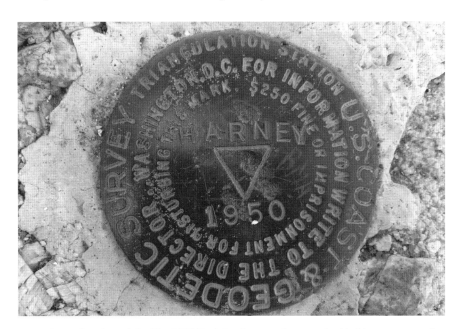

The primary benchmark for Black Elk Peak is a bronze plaque embedded in concrete and inscribed with "Harney" and the year 1950. *Photo by Bradley D. Saum.*

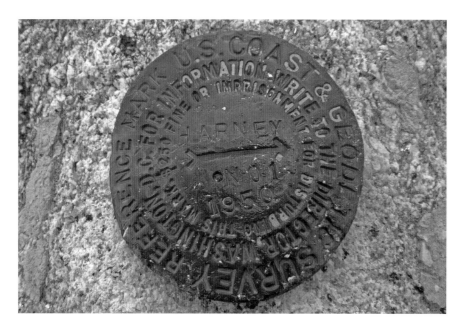

A bronze reference marker labeled Harney No. 1 was positioned twenty feet northeast of the airway beacon that was once atop Black Elk Peak. *Photo by Bradley D. Saum.*

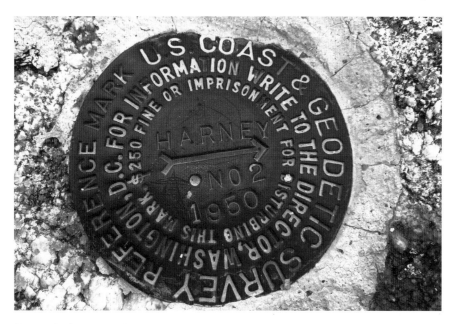

A second reference marker, Harney No. 2, was placed twenty-five feet northwest of the airway beacon that was once atop Black Elk Peak. *Photo by Bradley D. Saum.*

would have originally been cleared of trees and bushes to maintain a line of sight to aid in surveying. The exact location of a benchmark is determined by measuring distances and angles from other known benchmarks. Once calculated, the new benchmark can then be used as a reference point.

The U.S. Coast and Geodetic Survey is actually one of the oldest agencies in the United States. The agency was first established by President Thomas Jefferson in 1807 as the Survey of the Coast, and it continued to operate for the next seventy years. In 1878, the name changed to Coast and Geodetic Survey to be more in line with the increase in work being completed throughout the interior of the country. In 1970, the agency became the National Geodetic Survey and operates under NOAA within the United States Department of Commerce.

Surveyors are concerned with visibility to other benchmarks and may not always place the bronze marker at the precise highest point. The purpose is not to identify the actual peak but rather to serve as a triangulation station.

CAMERA POINT

Theme parks often have signs carefully positioned that provide recommendations on where to take those iconic pictures with the most popular attractions framed like postcards. Although for entirely different intentions, the U.S. Forest Service had a very similar system, which included the camera-point designation on the west side of Black Elk Peak.

Embedded in the granite is a small round bronze plaque that reads, "U.S Department of Agriculture Forest Service Camera Point No. 7." And although this does provide an ideal location to photograph the summit and fire lookout tower, the purpose is to conduct scientific research, not to provide the classic postcard view of the high point.

The first chief of the U.S. Forest Service, Gifford Pinchot, was also the first forester to incorporate photographs into descriptions of the effects of resource management practices implemented to protect the nation's forests. Another forester, Kenneth Swan, began his career with the forest service in 1911 and was critical in developing and implementing the Camera Point Program.

Swan had master's degree from Harvard University when he joined the newly formed U.S. Forest Service. Stationed in Missoula, Montana, he was an avid photographer, documenting the land and people of the forest service throughout his entire career until he retired in 1947. Swan successfully combined two passions, photography and forestry, into one career.

Forests are constantly changing through the impact of new growth, fire, weather, land use, timber harvesting and myriad other natural and man-

made influences. To better understand this change, a specific camera point is identified and pictures are taken from the exact same location at regular intervals over a period of time. The comparison of each of these photos, along with other records such as measurements and descriptions, provides a valuable research tool to understand change over time.

The concept of leveraging photos taken at various time intervals can be represented by school photos taken each year at about the same time. The change in maturity is captured, and comparisons can be made between the different photos as the student ages year after year. Even slight changes in appearance become noticeable when comparing multiple images.

The use of the Camera Point Program was for scientific study to gain a better understanding of the ebb and flow of the ecosystem. In forests, the changes in the growth and density of trees, amount of underbrush and species of plants growing can all be noted. Comparisons can be made between the various photos and data compiled to document the changes occurring in the forest. The key to the program is to locate the little bronze marker and take the photos from the same location each time. This ensures a valid comparison of the exact same area.

The Camera Point Program is an official program of the U.S. Forest Service, and Camera Point Number 7 is positioned up on the summit of Black Elk Peak.

GUIDING LIGHT

Traversing the country by airplane was recognized as a critical method for the U.S. Postal Service to move mail in the 1920s. Pilots were guiding their way by looking out of their cockpit to identify landmarks below. This method proved to be less than efficient, and there was no technique to navigate after dark, when the landmarks below were not visible.

Moving mail by air was not necessarily a new concept. George Washington penned the first airmail letter, which was delivered by Jean-Pierre Blanchard on the first balloon flight in North America. The first official airmail originated

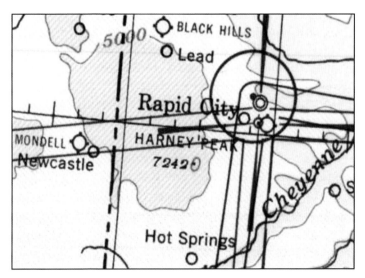

Harney Peak, as it was named until 2016, is denoted on this aeronautical chart published in 1954 by the U.S. Coast and Geodetic Survey. *NOAA's Historical Map and Chart Collection.*

in Lafayette, Louisiana, in 1859, again by balloon. The use of the airplane to deliver mail was introduced with a test flight in 1911.

It was when the airmail efforts sought to expand with nighttime flights that the U.S. Postal Service intersected with the highest point in the Black Hills. The challenge to provide a means to navigate airway corridors was tested with the use of bonfires to light a nighttime passage across the Midwest in 1921. Two years later, the U.S. Army experimented by guiding pilots through the darkness with lights strategically stationed along a seventy-two-mile route in Ohio.

These successful tests laid the foundation for the U.S. Postal Service to develop a transcontinental route guided by lights beginning in 1923. The solution was beacons, consisting of lights visible from a distance of forty miles, providing pilots with the ability to begin nighttime flights in 1924.

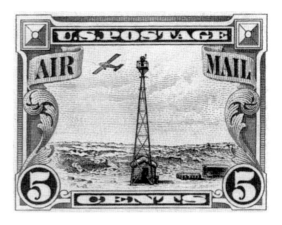

Right: The airway beacons, similar to the one that was perched on Black Elk Peak, were memorialized in 1928 on the five-cent Beacon Air Mail stamp. *U.S. Postal Service Stamp.*

Below: The airway beacon atop Black Elk Peak on May 25, 1945, provided a guiding light for airplanes crossing the country. *U.S. Forest Service.*

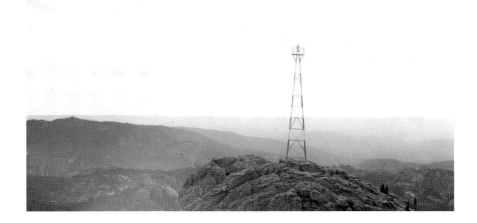

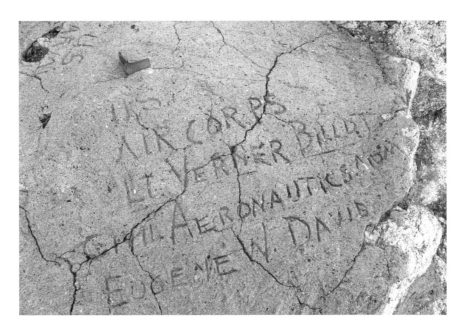

Presumably scribed by those erecting the airway beacon in 1943, several names can be found carved in the concrete near a piece of the original steel support. *Photo by Bradley D. Saum.*

"U.S. Army July 1943" remains etched in the concrete that supported the airway beacon, which included a rotating light mounted on a steel structure. *Photo by Bradley D. Saum.*

Depending on location and weather conditions, the lights were occasionally visible even farther, up to nearly one hundred miles. What followed was a network of thousands of beacons to provide guiding light to pilots as they crisscrossed the nation.

The beacon was a white light that rotated and generated a rapid flash that lasted about one-tenth of a second and repeated this flash every ten seconds. This light was easily seen from the air and could be distinguished from any surrounding lights.

Constructed during the Second World War, the Harney Peak Airway Beacon was a formidable steel structure nearly sixty feet tall and painted orange and white. Stroking their names into the soft concrete laid as a foundation for the beacon tower, two U.S. Army airmen left their permanent mark—"US ARMY JULY 1943" was etched into concrete supporting the tower.

Frequently, these airway beacon towers were built on a huge concrete arrow pointing the direction to the next beacon. This would only be possible on flat ground, and Black Elk Peak was certainly not conducive to constructing a huge arrow into the rugged granite.

The airway beacons were instrumental in the progression of mail delivery and were recognized by the U.S. Postal Service with a five-cent Beacon Air Mail stamp in 1928. The light shining from atop Black Elk Peak provided a navigation point that was used in conjunction with other beacons, forming an aerial roadway.

Aircraft navigational aids steadily evolved and eventually included onboard computers. The evolution of technology gradually resulted in deprecating the shining lights. The last airway light beacon from the system that began in the 1920s was shut down in 1973.

On the Black Hills high point, the legs were later literally cut from under the Harney Peak Airway Beacon. The steel stumps firmly rooted in concrete remain at the peak, documenting a chapter in aviation history.

Mailed from 7242

Twenty years before ZIP codes were established and fifty years before the first electronic text message was sent, those who reached the summit could easily mail a letter or postcard to friends and family. Perhaps exhilarated by the accomplishment, inspired by the view or motivated by the uniqueness of their experience, tourists could document their visit and use the official Harney Peak Post Office to send their mail.

The U.S. Post Office operated during the summers at Black Elk Peak from 1936 to 1942 and from 1945 to 1946 and included a custom postmark, "Harney Peak, S. Dak." The bull's-eye hand cancellation stamp from the Harney Peak Post Office is the common circular design with the location around the top, the state around the bottom and the month, day, year and time in the middle of the circle. Originally developed as a method to prevent reuse of postage stamps, the cancellation served a more commemorative purpose for those mailing from the summit.

Mail delivery has been seen as a priority even in the early days as the country was merely forming. Benjamin Franklin was appointed the first postmaster general by the Continental Congress in 1775. Postage stamps as the primary method of payment were introduced in 1847, and prior to stamps, it was typical for the recipient to pay the postage. However, the requirement for nearly all mail to be prepaid was instituted in 1855.

The famous Pony Express started in 1860 but only operated for about eighteen months. The last known stagecoach robbery of mail in the

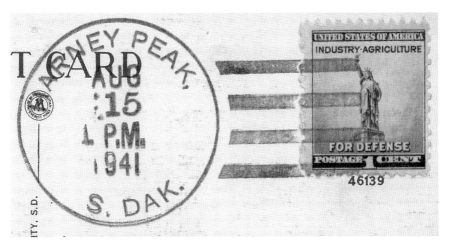

A one-cent stamp sufficed for mailing a postcard from the summit of Black Elk Peak and received an official August 15, 1941 Harney Peak Post Office postmark. *U.S. Postal Service.*

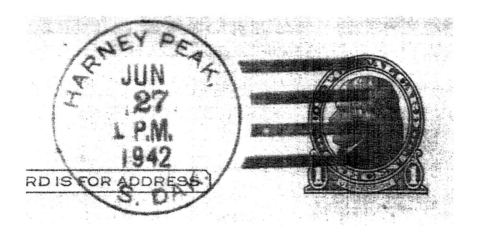

Visitors were able to mail cards from the Harney Peak Post Office, which operated during the summer from the summit. *U.S. Postal Service.*

United States occurred in 1916 on the route from Rogerson, Idaho, to Jarbidge, Nevada. The perpetrators were quickly identified and captured five days later.

By the time the Harney Peak Post Office was operating, there were more than forty-four thousand post offices throughout the United States. These post offices employed just over 250,000 people, who managed the delivery of 27 billion pieces of mail annually. Among the billions of pieces of mail

were the postcards on which tourists quickly scribed notes and mailed from the highest peak in the Black Hills.

There were many post offices that have operated seasonally at tourist areas since 1891, and possibly even earlier. The vast majority of these locations only operated in the summer, while a small number of others were only open in the winter. Harney Peak was one of the 1,679 seasonal post offices and was only operational during the summer months.

The cost to mail a postcard with the Harney Peak Post Office cancellation was merely a one-cent stamp. The price of a stamp for a postcard did not increase to two cents until 1952. A letter could be mailed with a three-cent stamp, and that price did not increase to four cents until 1958. Postage was one standard rate regardless of origin, so there was no additional charge for mail originating from the high granite peak.

Florida was home to more seasonal post offices in the winter than any other state, while California had more summer post offices than any other state. Seasonal post offices housed in other park areas included Old Faithful (Yellowstone National Park) in Wyoming, Kings Canyon National Park in California and Yellowstone in Montana, among many others.

The overwhelming majority of mail from Black Elk Peak was outgoing postcards from visitors who would send messages to friends, neighbors and family long before e-mail and text messaging made instant communication

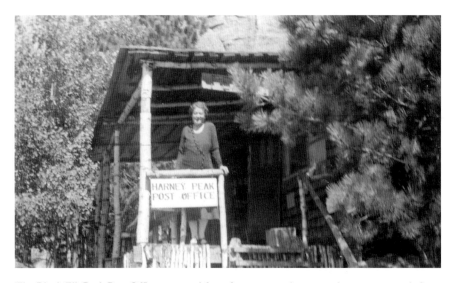

The Black Elk Peak Post Office operated for a few years and processed many postcards for the visiting tourists who made the trek to the summit. *U.S. Forest Service.*

possible nearly everywhere. It was not uncommon for people to return home before their friends and family received the postcards that had been mailed on their trip—very different from the multitude of social media options now available allowing for instant communication.

The nearest post offices to Black Elk Peak today are in the surrounding cities of Custer, Hill City and Keystone, as well as the Crazy Horse Post Office located at Crazy Horse Memorial. Letters and postcards can still be mailed from the traditional post offices and mail drop boxes throughout the region.

Responding to an inquiry to describe the city where the Harney Peak Post Office was located, Belle Stewart, postmistress at Black Elk Peak in 1942, replied on a postcard, "It aint." Then she further detailed that the post office was the site of thousands of visitors who reached the summit of Harney Peak either by foot or horseback.

The Harney Peak Post Office was discontinued on December 31, 1946.

ASPIRING MUSICIANS

It's not the typical stage for a musical performance, but nothing about Black Elk Peak is typical. The symphony resonated from the mountaintop in 1921 after twenty determined Boy Scouts ascended Black Elk Peak on foot, carrying all their instruments.

On a tour of the Black Hills, bandmaster Dave Clark organized several concerts for the Boy Scouts at popular venues in the region, such as Hot Springs, Wind Cave, Spearfish and Sturgis. On June 6, 1921, the stage just happened to be at 7,242 feet.

The twenty Boy Scouts who hiked to the summit of Black Elk Peak were members of Troop 1 of Lemmon, South Dakota. The city of Lemmon is located about 250 miles north of Black Elk Peak right along the state line with North Dakota.

Under the leadership of Scoutmaster E. Dickinson and assistant Charles Olson, they took their instruments in hand and hiked to the summit. No shortcuts were taken in producing the perfect sounds, as all the instruments, including a bass drum and several large horns, were all manually toted along the trail.

Although the sounds resonated throughout the valleys below, visitors at Sylvan Lake Lodge and officers at the Forest Service Office in Custer, South Dakota, were able to listen as the Boy Scout concert was broadcast live to both locations. Both tourists and forest service officers listened via telephone, broadcasting the Boy Scout concert at Black Elk Peak from the fire lookout tower.

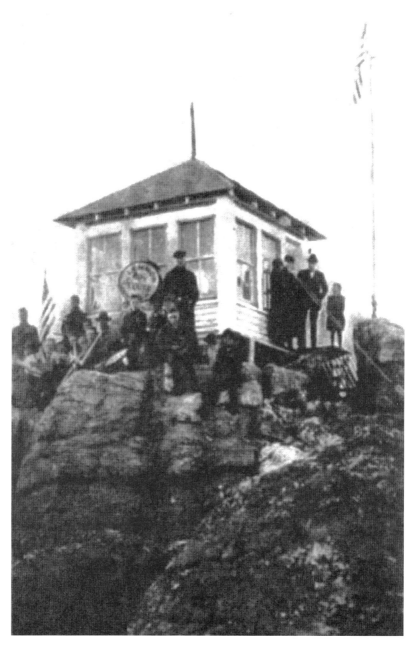

Boy Scout Troop 1 from Lemmon, South Dakota, presented a band concert at the peak on June 6, 1921, after packing in all the instruments. *American Forestry, September 1921.*

BLACK ELK PEAK

Twenty Boy Scouts playing their instruments at the summit of Black Elk Peak after hiking with those instruments up the more than three miles to the peak is among the many unique and curious events that have occurred at the highest point in the Black Hills. Each of these individual events is a small portion of the history that combines like pieces of a puzzle to present one interconnected image.

THE BADGER

With his breeches neatly tucked into his classic leather riding boots and adorned with a cowboy hat, Charles Badger Clark maintained a simple yet influential presence in the Black Hills. Badger Clark, as he was affectionately known, leveraged his personal experiences at a cattle ranch in Tombstone, Arizona, to capture the essence of an unpretentious cowboy lifestyle in lines of poetry. His many years in the Black Hills inspired his poetry, reflecting a genuine appreciation for the transparent and natural beauty that surrounded him.

Clark was born in Albia, Iowa, on New Year's Day in 1883, but his family soon moved to the Dakota Territory, settling in Deadwood. He attended Dakota Wesleyan University for one year following high school. By choice or by necessity, Clark embraced the adventurous spirit within and landed a job at a plantation in Cuba.

His experience in Cuba ended when he was found in the wrong place at the wrong time, charged with carrying a gun without a license and stealing coconuts. He was eventually acquitted and returned home to the Black Hills. Later, when he contracted tuberculosis, he took a doctor's advice and immediately headed to the dry air of the Southwest.

Clark enjoyed the unfamiliar environment and his immersion into the unique cowboy culture. He documented his newfound inspiration in poems, which he occasionally sent back to his stepmother, Anna Clark, in South Dakota. Ignoring Clark's humility, Anna submitted the poem "Ridin'" to *Pacific Monthly* magazine. Not only was it published, but there was also a ten-dollar payment.

After four years in Arizona, Clark returned to the Black Hills in 1910 to care for his ailing father. During the next ten years, he also gave lectures and wrote poetry, publishing *Sun and Saddle Leather*, a collection of his poems, in 1915. This was followed two years later by *Grass Grown Trails*, and the foundation was quickly laid for Clark's significance as a poet.

The year 1937 proved to be monumental for Clark. He finished building his quaint cabin in Custer State Park, constructed of native ponderosa pine and local rocks; he would live there for the next twenty years. More significantly, in the same year, Governor Leslie Jensen named Clark the first poet laureate of South Dakota.

Construction on the stone fire tower that stands as a crown on Black Elk Peak was also substantially completed in 1937, with minor finishing details wrapping up over the next year. One of Clark's visits to Black Elk Peak in 1937 was captured in a photo. Clark is seen posing on the stone deck with Mrs. Howard Culver, the wife of the first U.S. Forest Service fire lookout to reside in the recently finished fire tower.

During his years in the Black Hills, Clark was known to roam the hills and valleys and made positive contributions in support of Custer State Park. He authored a booklet titled *Custer State Park, Black Hills of South Dakota*, a rather comprehensive history of the region. He included a brief reference to the many improvements made by the Civilian Conservation Corps, including "picturesque stone towers for the fire lookouts on Black Elk Peak and Mount Coolidge." His eclectic style, sharp dress and firm grasp on simple pleasures made him a welcome and popular speaker at many occasions across the state.

Although Clark embraced his interactions with others, it was carefully balanced with personal alone time in the Black Hills, as evidenced in "Myself and I":

> *Let me get out in the hills again,*
> *I and myself alone,*
> *Out through the wind and the lash of rain*
> *To find what we really own.*
> *Under the stars while a campfire dies*
> *Let me sit and look myself in the eyes.*

Perhaps Clark is best known for his readily recognized "A Cowboy's Prayer," first published in 1906 and subsequently published more than sixty times during his lifetime. This poem has appeared on many postcards

Badger Clark, South Dakota's first poet laureate, and Mrs. Howard Culver at Black Elk Peak on August 23, 1937. *U.S. Forest Service.*

and ultimately helped to secure permanency of Clark's informal title of "Cowboy's Poet."

At the age of seventy-four, Clark died in 1957. His cabin, which became widely known as the "Badger Hole" during his lifetime, was purchased by the South Dakota Department of Game, Fish and Parks. It was dedicated as the Badger Clark Memorial in 1958 and remains largely as he left it. Numerous boots for just about any occasion are neatly aligned in his bedroom, his vast collection of books remains on the shelves and his kitchen is ready for his next meal.

South Dakota's first poet laureate was drawn to Black Elk Peak, and during his travels of the Black Hills, he made the hike to the fire lookout tower. His cabin, located in Custer State Park, is open to the public during limited hours.

BEARD AND EARHART

One of the few women engaged in forest service work in the early 1920s, Mrs. Paul Beard climbed the twenty-foot ladder to the glass-enclosed top and spent her summers on fire watch. Black Elk Peak had an entirely different appearance in those days; the solid stone structure currently capping the peak was not constructed until 1938, many years later.

There was a small log cabin that served as living quarters just below the summit. Food and supplies were transported the nearly four miles on the backs of burros. Drinking water, not readily obtained on the granite peak, was carried several miles in bags to the summit. The daily duty for Beard was to watch the valleys below for smoke rising gently above the pine, indicating a forest fire, and communicating by telephone to the forest service for quick suppression.

The unique and curious activities of Beard, especially for a woman in the U.S. Forest Service, captured the attention of several newspapers in 1928. Several short articles were published in newspapers such as the *Aurora Daily Star*.

Catching her attention, Amelia Earhart, the remarkable aviation pioneer and author, clipped the newspaper article describing the forest service career of the woman atop Black Elk Peak. Earhart saved several newspaper and magazine articles describing unique careers of women. Some of these articles would later be compiled into a personal scrapbook Earhart entitled "Activities of Women."

Because of Beard's work in helping to protect the Black Hills from fires, a remote connection evolved between the high point and Earhart, who had made an indelible impression on the American public.

ENEMY SPOTTER

Typically, the eyes of the lookout were focused on the forests below, looking for rising smoke, but during World War II, there was an occasional glance to the sky. Watching the Black Hills for fire was routine for Byron Hazeltine, who was employed by the U.S. Forest Service for almost twenty years to staff the lookout tower.

Hazeltine was also trained to identify passing aircraft, specifically looking for Japanese balloons or military planes invading the United States. Although watching for an aerial invasion was a more critical function closer to the western shore, Hazeltine could identify aircraft simply by silhouette as they passed over the Black Hills.

In 1941, the Aircraft Warning Service became active under the United States Army to identify when enemy bombers entered American airspace. Watching the skies for enemy aircraft was a primary job for some, a collateral duty for others and simply a hobby for many more. In some locations, towers were built near the ocean for the sole purpose of maintaining a watch for invading aircraft. In other areas, existing towers, such as fire lookouts, were logically leveraged to scale the sheer number of trained eyes monitoring the sky.

Although training for some was formal, many hobbyists were also interested, and this resulted in the famous weekly radio program *Eyes, Aloft!*, hosted by the National Broadcasting Company. Henry Fonda was involved in these educational programs, which eventually spanned sixty-one episodes.

These lookouts monitoring the sky were arguably more critical on the coasts, but Hazeltine kept his trained eye on the airspace over the Black

Hills. The Aircraft Warning Service came to a close in May 1944 as the risk of invading aircraft approaching the United States was deemed to be minimal.

There was a natural fit with the forest service fire lookouts to help defend the country in a civilian capacity by maintaining an eye on the skies while perched atop high points across the country. The fire lookout tower on Black Elk Peak was no exception, and a glance upward would occur anytime a plane flew overhead. Defending the country against aerial attack was a noble addition to the duties of protecting the people, property and forests of the Black Hills.

Hurricane News

When an editor decides to live in a remote cabin and finds himself without the luxury of a newspaper to read, the result is a *Hurricane*. This newspaper of four pages—each formatted with two columns and properly fitted with the conventional title, editorial, news, cartoon and verse—was the creation of Earl H. Emmons. Called the *Harney Peak Hurricane*, the newspaper was published on June 3, 1919, from a small cabin just below the Black Elk Peak summit.

Seeking an adventure and break from being a news editor with the *American Printer*, Emmons opted for an extended stay at Black Elk Peak, living ten miles from the nearest railroad and more than three miles from the summer resort of Sylvan Lake. Rangers would bring sufficient supplies for a month to the end of the wagon road at Sylvan Lake, and it would take Emmons a week to haul it the remaining four miles up the trail to his cabin.

Lacking a proper printing press, *Harney Peak Hurricane* was handwritten and copied with the use of a hectograph, an early printing process involving the transfer of the original to a gelatin pad pulled tight over a metal frame. The first and only newspaper published at Black Elk Peak was short-lived and never progressed beyond the first edition.

A notable author, including such works as *Odeography of B. Franklin*, *Redskin Rhymes* and *Hell-Raisers of History*, Emmons penned the following verse while atop Black Elk Peak:

Black Elk Peak

Somewhere the sun is shining; somewhere the sky is blue;
Somewhere the birds are singing 'mid flowers of brilliant hue;
Somewhere the waters bubble, gurgling along the creek;
Some places June means summer—but not on Harney Peak.

Somewhere the grass is waving; somewhere the fields are green;
Somewhere the grain is nodding with shining golden sheen;
Somewhere on verdant meadows the herds graze, fat and sleek;
Somewhere there's warmth and laughter—but not on Harney Peak.

Somewhere there's ice and snowdrifts filling the nooks and dells;
Somewhere the winds are howling worse than the seven hells;
Somewhere the nights are zero; and the days are chill and bleak;
Somewhere it's winter all summer and that's on Harney Peak.

ONE OF THE OLDEST

Black Elk Peak stands tall over one of the oldest and most complex mountain ranges on earth. Aging beautifully, the solid footing provided by Black Elk Peak formed more than 1 billion years ago. The Black Hills can be described as an island in the plains, rising above the surrounding landscape.

The granite protrudes three thousand feet above the surrounding plains and is bordered by the Belle Fouche River to the north, the Cheyenne River to the south, the Buffalo Gap National Grassland to the east and the Thunder Basin National Grassland of Wyoming to the west. It is a true island rising from the plains.

A large igneous body of magma cooled below the earth's surface some 1.7 billion years ago, forming the granite but leaving it neatly concealed. Had it burst through the earth's crust, the geological formations associated with a lava flow would have resulted. The Harney Peak granite that was formed is fine-grained and speckled with little veins of large crystals called pegmatite.

Badger Clark, South Dakota's first poet laureate and longtime resident of Custer State Park, eloquently described the formation as "a disappointed volcanic eruption" that "failed to break through the crust and slowly cooled into granite." Putting the age into perspective, Clark wrote that the Black Hills "were doing business as a mountain range when the Alps were a plain and the Himalayas a swamp."

Likely exposed before the Cambrian times, the granite was covered by sandy sediment when the Cambrian Sea covered the Black Hills about 550

The Needle's Eye is a popular Harney Peak granite formation in the Black Hills that resembles the eye of a needle. *Photo by Bradley D. Saum*

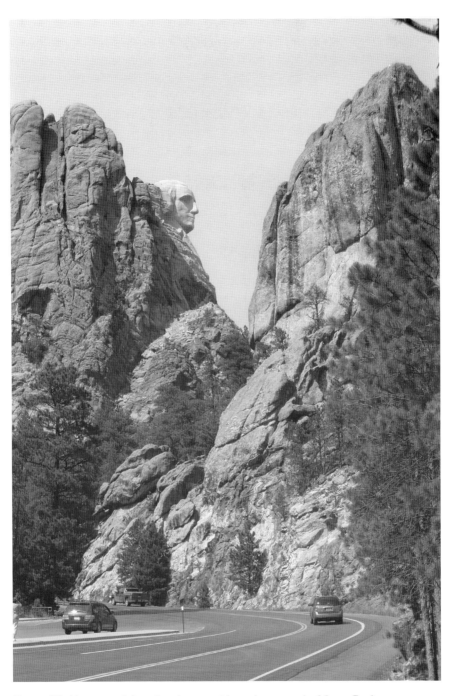

George Washington and the other three presidents that comprise Mount Rushmore National Memorial were carved into Harney Peak granite. *Photo by Bradley D. Saum*.

million years ago. But it was more recently, roughly 60 million years ago, when the region experienced turbulence and the granite was thrust upward, exposing it to surface weathering.

The mountains likely rose to fifteen thousand feet above sea level. Routine erosion generated by the effects of water, wind and variant temperatures created the exposed surfaces seen today. Near Black Elk Peak, the granite features narrow pillars with little pointed peaks. These prominent natural formations are known as the Needles and are located in the northwest section of Custer State Park in the general vicinity of Sylvan Lake and the trailhead to Black Elk Peak.

There is clear evidence of rock formations across a broad timeline proceeding from the center of the Black Hills and expanding outward to where the pines meet the grasses. The progression includes a glimpse of the Precambrian, Paleozoic, Mesozoic and Cenozoic Eras.

Throughout the Black Hills, there are mineral deposits and rock beds featuring quartz, copper, silver, lead, mica, feldspar and many other naturally occurring geological finds. Gold, uranium, pegmatite minerals and limestone are also found in the region.

The Rocky Mountains are mere infants in comparison to the Black Hills. A geological landscape similar to the Black Hills will evolve as the

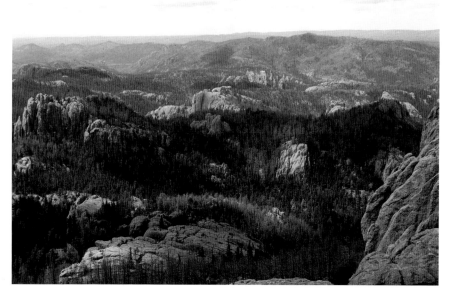

Harney Peak granite formed about 1.7 billion years ago, and the exposed rock can be seen throughout the Black Hills from the summit. *Photo by Bradley D. Saum.*

A History

Rockies erode over the next 50 million years. The granite forming much of the Black Hills is especially resilient, eroding only a fraction of an inch every 1,000 years.

PLANTED AND RUNNING

The distinctly sweet aroma of the ponderosa pine is unmistakable and summons the essence of a sweet candy store that can nearly be tasted. The pine is foundational to the Black Hills and dominates the vast view from atop Black Elk Peak.

The color black was used by the Lakota to represent the westerly direction. Therefore, the Lakota name for the Black Hills, Paha Sapa, refers to the location of the hills in the westerly direction. However, as European settlers arrived, the dark hue created by the deep green pine needles blanketing the region amplified the use of the descriptive name Black Hills.

On the slopes of Black Elk Peak, the long needles of the ponderosa pine are accompanied by the boughs of the Black Hills spruce, leaning lazily toward the ground. Sprinkled around Black Elk Peak, the Black Hills spruce is the state tree of South Dakota. Along the trail to Black Elk Peak, quaking aspen, bur oak and paper birch trees are clustered along streams in areas where sunlight breaks through the canopy.

The climax community is dominated by the ponderosa pine, but when there are disturbances such as the pine bark beetle and the canopy opens, the grasses, shrubs and deciduous seedlings thrive. Eventually, the ponderosa pines grow to cast their shadow and dominate the area.

Brilliant colors sparkle throughout the landscape as flowers bloom in contrast to the dark forest. The orange of the endangered wood lily, the blue of the spiderwort and the purple of fireweed generate a rainbow of colors sprinkled among a backdrop of green ferns.

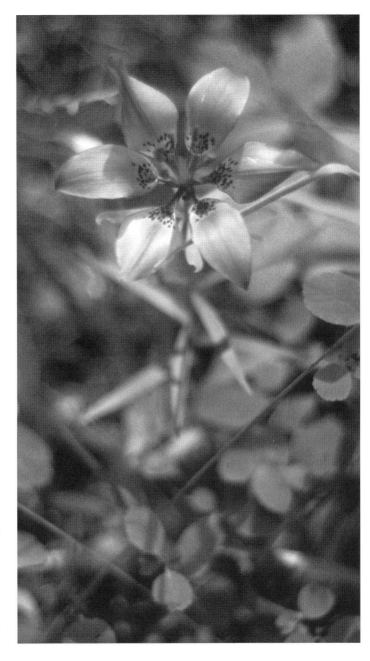

The endangered wood lily, with the orange petals popping out from the surrounding green plants, can be found in Black Elk Wilderness. *Photo by Bradley D. Saum.*

Although Black Elk Peak is well below the tree line, the actual summit is mostly barren granite. However, the rocky island of the peak is surrounded by vigorous plant growth. The Black Hills are a convergence of habitats hosting

The three blue petals of the spiderwort only last one day—they open early in the morning and are typically wilted by the heat of midday. *Photo by Bradley D. Saum.*

a diversity of wildlife. In this area where the plains meet the mountains, eastern and western species overlap and wildlife is abundant.

Precariously perched on the exposed granite, the white contrast of the mountain goat tantalizes the eye. The Rocky Mountain goat, though not indigenous to the area, is an occasional visitor to the granite summit of

The Rocky Mountain goats are very adept in the rocky terrain and thrive in the area around Black Elk Peak and Mount Rushmore. *Photo by Bradley D. Saum.*

Black Elk Peak. The mountain goats were introduced into Custer State Park from Canada and discovered the rocky outcroppings around Black Elk Peak perfectly suitable.

Naturally traversing the rugged rock, the curled horns of the bighorn sheep draw a second glance. The original species of bighorn sheep that inhabited the area around Black Elk Peak is now extinct. However, a similar species was successfully introduced and thrives in the rocky region surrounding Black Elk Peak.

At the summit, least chipmunks scamper busily across the rocks. Attracted to the crumbs left behind by hikers snacking on their lunches, the chipmunks are one of the few animals that inhabit the granite summit. Mountain lions and coyotes would be an extremely rare sight but are among the wildlife that could potentially pass by the summit. Deer are commonly sighted along the trails leading to the peak but rarely venture to the top of Black Elk Peak.

The famous wildlife of the plains, such as buffalo, pronghorn antelope and elk, frequent the lower elevations and regions, where there are more open grasslands. The granite summit of Black Elk Peak is not a conducive environment for grazers seeking grass and other plants.

Early in the morning and especially in the lower elevations, hikers may see deer grazing in the grassy meadows along the trail. *Photo by Bradley D. Saum.*

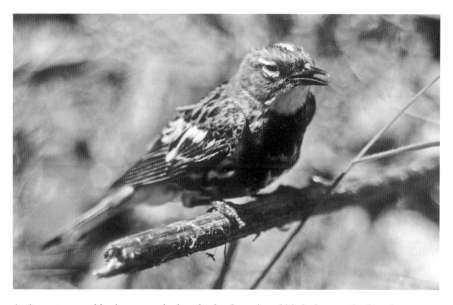

An immature warbler is among the hundreds of species of birds that can be found throughout the Black Hills. *Photo by Bradley D. Saum.*

Preferring high, moist elevations, the Black Hills redbelly snake is rarely seen but likely a resident throughout the Black Elk Wilderness surrounding Black Elk Peak.

Soaring high above, there are hundreds of species of birds that reign throughout the Black Hills. A unique habitat where both eastern and western birds comingle, a watchful eye from the summit is sure to observe the feathered flyers.

Black Elk Peak is a popular destination, making it the least wild part of the Black Elk Wilderness. Many creatures thrive in the area, but the sightings on the peak are not as frequent as other parts of the Black Hills.

EPIDEMIC

The dark-green tone of the ponderosa pine trees is interrupted with patches of rusty brown that mark the destructive path of the mountain pine beetle. The beetles are spreading throughout the Black Hills National Forest and destroying acres and acres of pine trees.

The infestation of the mountain pine beetle has been at epidemic levels in recent years, attacking the ponderosa pine trees. There are obvious signs of the damage throughout the hills, as complete hillsides turn brown as the dead pine trees are left standing with no needles. The forest floor eventually becomes littered with the fallen timber.

Living the majority of its life in the inner bark of ponderosa pine trees, the mountain pine beetle is a small insect that is native to western North America. Being native to the Black Hills, the beetles typically prey on the weaker trees and serve a positive ecological function in the natural balance and regrowth of a forest.

However, a drought and mild winters have fueled a major outbreak that started in 1997 in the northern hills and has since moved south through Black Elk Peak and beyond. In 2001, small pockets of the pine bark beetle were first observed in Custer State Park just to the south of Black Elk Wilderness.

There are four stages to the life cycle of the mountain pine beetle: nymph stage, adult stage, egg stage and larvae stage. The beetle spreads to other trees in large numbers from late June through September, when it is able to fly in the adult stage. Their ability to fly is not great, and they typically travel no more than about three hundred feet from the tree where they spent most of their life.

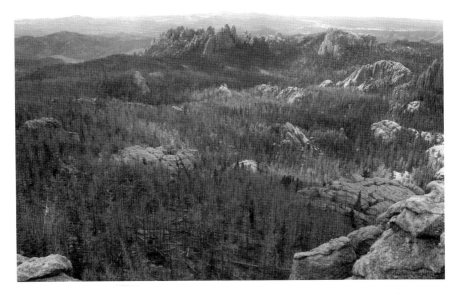

Dead and dying trees stand without needles, marking the destructive path of the pine bark beetle around Black Elk Peak. *Photo by Bradley D. Saum.*

When they land on a tree, the beetles then bore into the bark to lay eggs, and the cycle repeats. The tree secretes a resin, or pitch, as a defensive mechanism. The pine bark beetle is able to bore through the bark, and the dust created as the beetle makes progress can turn the resin a reddish tint as it drips down the tree. The beetles lay eggs just below the bark and deploy a fungus that protects their offspring but disables the tree's ability to transport water and nutrients. The combination of the beetles eating and the fungus colonizing quickly kills the tree in a matter of weeks.

A large portion of Black Elk Wilderness, including the Black Elk Peak area, has experienced widespread impact. The dark-green needles turn red and eventually gray before falling to the ground, evidence that the tree has died. The dead trunk and branches stand naked until, in its weakened state, it collapses to the ground.

In addition to the devastating impact of the dead pine trees, the threat of wildfires dramatically increases. The dead and dry timber provides excellent fuel for a wildfire, as well as the means for the fire to spread. The mechanism of defense is thinning the forest, removing the weaker trees and promoting fewer but more vigorous trees. Removing the infested trees for lumber helps to stop the beetle from spreading, as the larvae are killed during the drying process at

Pine bark beetles are engravers, boring tunnels in the surface wood that are later exposed when the bark separates from the tree. *Photo by Bradley D. Saum.*

Deadly artistic impressions are created by a gallery of tunnels that were chewed into the wood just below the bark by the pine bark beetle. *Photo by Bradley D. Saum.*

the mill. Thousands of acres of trees have been thinned throughout the Black Hills in an effort to manage and contain the pine bark beetle infestation.

Trees can also be sprayed with a specific insecticide before any infestation to prevent a pine bark beetle attack, but the entire trunk up to a height of thirty-five feet must be sprayed until it is thoroughly wet. In the mountainous terrain of the Black Hills, accessibility to trees in the dense and remote forest areas can be challenging, time consuming and prohibitively costly. Spraying is typically limited to resort and recreational areas, along roadways and on private land.

Black Elk Peak is located within a wilderness area, and this prevents the use of mechanized equipment and traditionally allows the forest to evolve naturally. To control the continual spread of the beetle, infested trees are cut into two-foot lengths that dry quickly, killing the larvae before the flying adult phase.

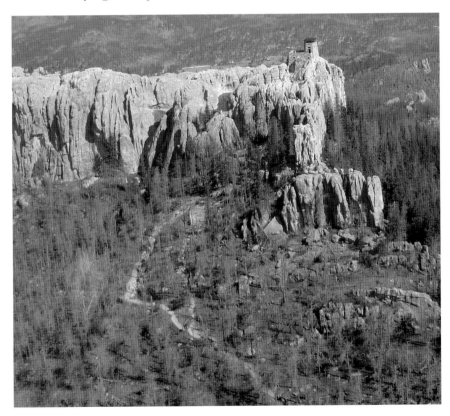

Fallen pine trees, having succumbed to the pine bark beetle, litter the hillsides around Black Elk Peak as new seedlings sprout from the ground below. *Photo by Bradley D. Saum.*

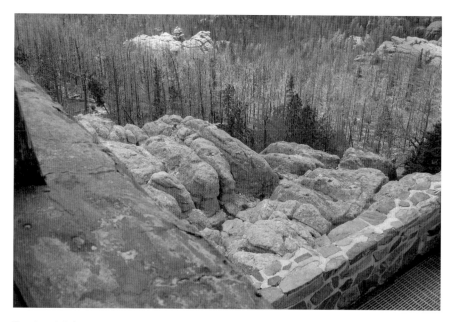

Dead and dying standing trees dominate the hillsides around Black Elk Peak and appear as large brown patches on the distant landscape. *Photo by Bradley D. Saum.*

From up on Black Elk Peak, the dark hue of the pine needles has been replaced with gray timber and barren landscape. All is not lost, as small evergreens sprout from the soil, through the layer of fallen needles. A new forest is slowly evolving to fill in the barren landscape and reclaim the natural beauty of the ponderosa pines covering the slopes.

PANORAMA

The panoramic scene is carpeted by the dark green of the ponderosa pine and the Black Hills spruce. Granite spires poke through the gentle waves of rolling peaks. The clouds drifting slowly through the sky are engulfed by a mixture of blues and pinks created by the setting sun. Filled with hidden life below, the darkness of the hills blends into the sky to become one uninterrupted scene. The view is speckled with sensory delights.

From natural marvels to significant landmarks, standing on Black Elk Peak allows the eye to take in four states, wander past a national monument, across a national forest, through a state park, behind a national memorial and beyond to a national park. Jewel Cave National Monument is hidden below the surface to the southeast, the Black Hills National Forest covers a large portion of western South Dakota, Custer State Park is just to the south of Black Elk Peak, Mount Rushmore National Memorial is just four miles to the northeast and Wind Cave National Park is to the south, while Badlands National Park is off to the east. The region is a tourist destination that presents the opportunity for a multitude of different experiences. Spanning four states, the view from Black Elk Peak includes Nebraska, Montana and Wyoming in addition to its home state of South Dakota.

The cathedral spires emerge from around Sylvan Lake in Custer State Park and stand unique among the various granite formations protruding from the forested landscape. Recognizable as the location where the climax to *National Treasure: Book of Secrets* was filmed, the granite around Sylvan Lake

Framed by the stone around the window, a vast view of the Black Hills fills the vista from the fire lookout tower at Black Elk Peak. *Photo by Bradley D. Saum.*

A commanding view of the surrounding Black Hills is visible from the summit, framed by a granite crevice. *Photo by Bradley D. Saum.*

provided the ideal backdrop for Nicolas Cage to locate the fabled Lost City of Gold.

Mount Rushmore is clearly visible, but the famous carving of four presidents is hidden on the opposite side, leaving Mount Rushmore National Memorial out of view from Black Elk Peak. Another notable landmark nestled in the Black Hills and not too distant from Black Elk Peak is Crazy Horse Memorial, the world's largest mountain carving of the Native American, on horseback. The view is blocked by the rugged natural landscape. By coincidence or by fate, neither of the huge man-made memorials can be seen from Black Elk Peak

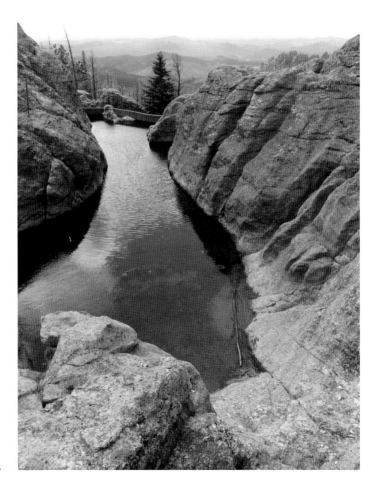

From the retention pond once used to supply water to the lookout tower, the view extends into the pine forests of the Black Hills. *Photo by Bradley D. Saum.*

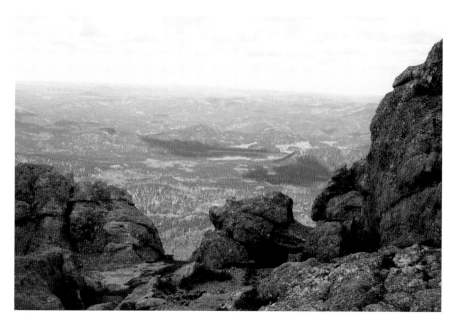

The varying terrain ranging from forests to grassland can all be seen from the top of Black Elk Peak. *Photo by Bradley D. Saum.*

The view from Black Elk Peak at 7,242 feet varies, with a multitude of different vantage points at the summit. *Photo by Bradley D. Saum.*

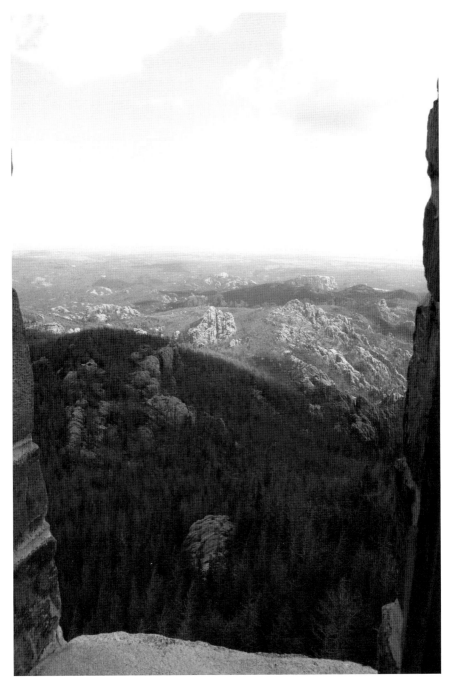

Black Elk Peak Lookout Tower provides an unobstructed view in all directions and is a worthy reward for the hike from Sylvan Lake to the summit. *Photo by Bradley D. Saum.*

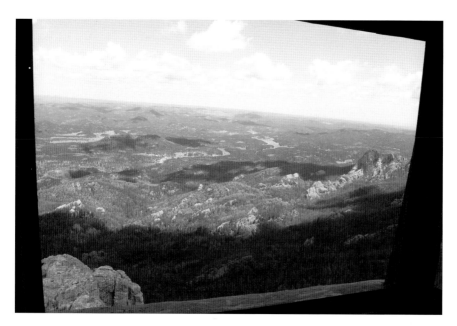

As the highest point, Black Elk Peak provides a panoramic view of Black Hills National Forest and beyond to the Badlands east of Rapid City, South Dakota. *Photo by Bradley D. Saum.*

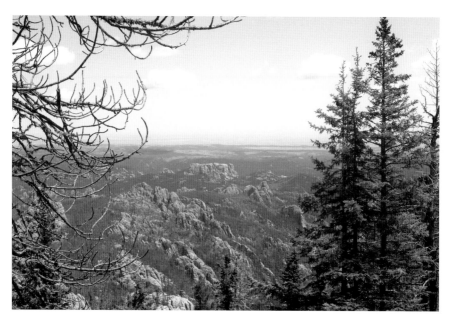

Granite rock outcroppings are sprinkled throughout the region, including the back of Mount Rushmore, which is visible from Black Elk Peak. *Photo by Bradley D. Saum.*

and therefore provide no distraction from the natural beauty that surrounds it.

The drastic change in landscape to the east highlights the transition of the Black Hills to the prairie that engulfs most of South Dakota. The eastern view is highlighted by a peek into geological deposits of Badlands National Park.

On the horizon, a glimpse of Devils Tower National Monument may even be visible on a clear day. Left standing millions of years ago as the adjacent sedimentary rocks eroded away, it now protrudes more than one thousand feet above the surrounding landscape. Interestingly, the Native American name was misinterpreted, resulting in an erroneous translation to "Bad God's Tower," later evolving to Devils Tower.

The panoramic view from the fire lookout tower above Black Elk Peak captures the attention at every turn as the forest, granite, plains, cities and roads all intermix to present a beautiful scene.

A GLIMPSE

Opportunities to catch a glimpse of Black Elk Peak exist throughout the Black Hills. Isolated by the surrounding thirteen thousand acres of protected wilderness, a glimpse of the highest summit requires a watchful eye. However, the prominent granite of Black Elk Peak can occasionally be observed from the hiking trails and roadways throughout western South Dakota.

The George S. Mickelson Trail wanders 109 miles through the heart of the Black Hills, passing to the west of Black Elk Peak along Highway 385 between Custer and Hill City. Accessible from fifteen trailheads, the trail traverses over one hundred converted railroad bridges and is utilized by hikers, bicyclists and horseback riders. At milepost 56.3, which is about 10 miles north of Custer, Black Elk Peak is visible to the east. Just under 8 miles farther up the trail, Black Elk Peak can be seen looking to the south from milepost 64, which is just on the north side of Hill City.

Within Custer State Park, Lover's Leap Trail and Stockade Lake Trail both offer ridge-top views of Black Elk Peak. The trailhead for Lover's Leap Trail is located on Highway 16A across from the Peter Norbeck Visitor Center. It is a three-mile loop trail that starts with a fairly strenuous incline and moderates to more level ground before descending. Stockade Lake Trail is also in Custer State Park off Highway 16A, with the trailhead located on the southeast side of Stockade Lake. This is a one-and-a-half-mile loop trail that is moderately difficult. Once up on the ridgeline, Harney Peak is visible.

Mount Coolidge Fire Tower, constructed by the Civilian Conservation Corps and which remains an active fire lookout, provides a majestic view of Custer State Park and beyond to Black Elk Peak. Mount Coolidge is located off Highway 87 between Blue Bell Resort and Highway 16A. There is a gravel road providing driving access to the fire tower during limited times of the day. The Needles Highway, part of the Peter Norbeck Scenic Byway, is a scenic route through Custer State Park that also provides a clear view of Black Elk Peak just past the Needle's Eye.

Willow Creek Loop Trail, originating just off Highway 16A near Mount Rushmore National Memorial, provides views while hiking in the Black Hills National Forest. The Willow Creek Loop Trail is an easy 1.5-mile loop road with great views of Black Elk Peak while meandering through some of the largest ponderosa pine trees in the Black Hills.

Breezy Point, a scenic overlook and picnic area along Highway 244 between Hill City and Mount Rushmore National Memorial, presents an opportunity to see the summit. This overlook is adjacent to the road and requires no hiking to gain a view of Black Elk Peak to the south. Various other roadways traversing Pennington and Custer Counties also offer glimpses of the peak.

Black Elk Peak can be viewed off in the distance to the south from Highway 244 between Hill City and Keystone, South Dakota. *Photo by Bradley D. Saum.*

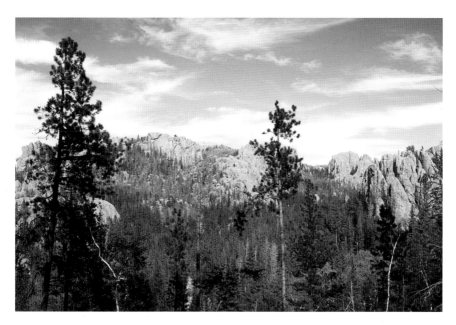

As the highest peak in the Black Hills, the fire lookout tower up on Black Elk Peak is visible in the distance from a few scattered locations in western South Dakota. *Black Hills National Forest.*

With the peak standing as the highest point in the Black Hills, views of the summit and the stone fire tower that protrudes even higher can be seen from many locations in and around Rapid City, Hill City, Keystone and Custer, South Dakota.

CLAIM DEBATE

As claimed on the bronze plaque firmly mounted at the summit, "The peak is the highest point east of the Rocky Mountains and west of the Pyrenees Mountains of Europe." Those few words have been challenged many times and are the basis for many friendly debates. Defending that claim mires one in technical definitions, geological nomenclature and geographical boundaries.

The 7,242-foot peak classifies Black Elk Peak as the highest elevation in the state of South Dakota. The state's high point claim is undisputable. The elevation changes more than 6,000 feet across the state, from the low point of 968 feet near the Minnesota border to the 7,242 feet of Black Elk Peak. Additionally, perched on the granite peak, the structure of the fire lookout tower extends an additional 35 feet above the altitude of the summit, positioned securely as the highest man-made site in the state.

Among state high points, it is fifteenth, as there are fourteen states with a peak higher in elevation than Black Elk Peak in South Dakota. Alaska is securely in first place as the state with the highest elevation, with Denali at 20,310 feet. The state with the lowest elevation is Florida, where Britton Hill stands to a height of merely 345 feet above sea level, although that is the highest point in the entire state.

Mountain peaks are often compared by their prominence, which is the height of the summit from the lowest contour around it. Prominence is how high the peak is compared the surrounding landscape. If the entire area around a peak were flooded with water, until that one peak was completely surrounded by the

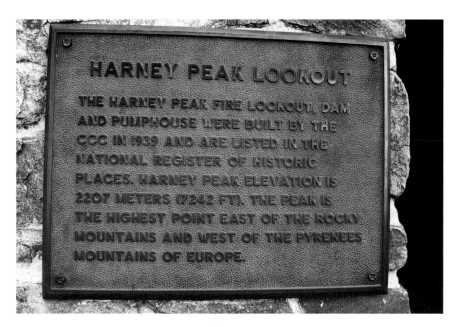

A plaque inscribed with the claim that Harney Peak, as it was previously known, is the highest point east of the Rocky Mountains generates much debate. *Photo by Bradley D. Saum.*

water and therefore creating an island, the height of that island represents the prominence. The prominence of Black Elk Peak is 2,922 feet.

Beyond the state's definitive high-point designation, the various other claims become less precise and easily arguable. The challengers often include other peaks in the eastern United States, but Mount Washington in New Hampshire has an altitude of 6,288 feet, Clingmans Dome tops the Smoky Mountains out at 6,643 feet and North Carolina claims the highest summit east of the Mississippi River, Mount Mitchell at 6,684 feet. All are notably below the 7,242 feet of Black Elk Peak.

The challenge extends to the claim that there is no higher mountain until the Pyrenees Mountains in France. The broad stroke of the naysayers rebut the claim by asserting that "east of the Rocky Mountains" would include peaks in the Dominican Republic, which soar well above 10,000 feet. Trying to define a region east of the Rocky Mountains is actually quite cumbersome, and even U.S. government agencies, such as the Board on Geographic Names, does not distinguish any regional boundaries within the United States. The Canadian Arctic, also east of the Rockies and Ellesmere Island, contains several high points, including Barbeau Peak (8,582 feet), higher than Black Elk Peak.

Therefore, continental limitations need to be inferred to keep the posted claim viable. But geographers even disagree on continent terminology, referencing the definition that America is a continent and North America is a subcontinent. Then there is further dispute over potential boundaries to distinguish Central America. Mexico is commonly included in North America by most geographers, and there are certainly peaks in the Sierra Madre Mountains that exceed Black Elk Peak and would be farther to the east. Greenland is considered part of North America and contains many higher peaks.

In pursuit of documented evidence, there is a footnote denoting Harney Peak, as Black Elk Peak was formerly known, as the "highest summit east of the Rocky Mtns." in a U.S. Geological Survey publication titled "Elevations and Distances in the United States."

Even the starting point for the claim, east of the Rockies, raises rather technical debates, as there are those geologists who claim that the Black Hills are part of the Rocky Mountains in the Laramide range. But then the same arguments ensue about the Guadalupe Mountains in Texas, which also have a stake in the high-point claim.

Going strictly by longitude, Black Elk Peak is well east of Guadalupe Peak (8,751 feet), which is the highest point in Texas, but slightly west of Emory Peak (7,825 feet), which is the highest peak in the Chisos Mountains of Big Bend National Park. That puts Emory Peak, whether it is technically part of the Rockies or not, about ten miles farther east than Black Elk Peak. For that matter, the Black Forest in Colorado is east of the Rockies, albeit barely, and has an altitude exceeding that of Black Elk Peak.

There is one definitive way to solve the debate: by a very strict interpretation and drawing a line directly between Black Elk Peak and the Pyrenees. Traversing the entire distance east, no higher peaks would be encountered along that line. A definitive solution, but also one that requires a very tight interpretation.

Regardless of the technical jargon debacle generated by geologists, geographers and the casual contender, Black Elk Peak remains curiously positioned in a debate for the title of highest peak. However, Black Elk Peak firmly holds the undisputed title as the highest peak in the Black Hills of South Dakota and the highest peak in all of South Dakota.

Getting There

S cenic overlooks are popular among tourists, and roads are frequently built where geographically feasible to allow the public access to the coveted views, especially in state and national parks. Small parking areas along mountain roads provide the driving public a chance to stop and absorb the natural beauty. Sometimes a few trees are even cut or trimmed to allow for unobstructed views.

Although Black Elk Peak is a unique high point with fabulous scenic vistas, there are no roads leading to the summit. However, it is entirely possible to reach the general vicinity and definitely drive close enough to catch a glimpse in the distance or ultimately park near the trailhead and make the hike to the summit.

The Black Hills are located in western South Dakota, a popular tourist destination famous for the many state and national parks in the area, including Mount Rushmore National Memorial, Wind Cave National Park, Jewel Cave National Monument and Custer State Park, along with a multitude of other attractions. Black Elk Peak is in the heart of the Black Hills in a remote wilderness area of Pennington County.

To reach the Black Hills by air, the Rapid City Regional Airport provides access via several major carriers. The terminal building for the airport opened in 1988, but a $20 million expansion and renovation was completed in 2012. Rapid City is immediately adjacent to the Black Hills, essentially right where the hills meets the plains. Sylvan Lake and the trailhead to Black Elk Peak are about thirty miles from the airport.

For those driving to the region, Interstate 90 crosses just on the north side of the Black Hills. Sylvan Lake is about sixty miles south of Interstate 90 on Highway 385. Only a few highways traverse the Black Hills, making some planning necessary. Cellphone service is sporadic at best, so having a map and a planned route is helpful.

It is also useful to make allowances for travel time, realizing that cities and attractions are quite spread out. The Black Hills region is more than one hundred miles north–south and more than fifty miles east–west. As a tourist destination, there is routinely traffic, especially in the peak summer months. The roads through the Black Hills require some extra care and attention, as they wind up and down and around the granite peaks.

Another option for reaching the area is by bus. Greyhound provides service to Rapid City. There is no public transportation connecting all the attractions in the Black Hills. Having access to a vehicle is critical. There are various sightseeing tours available in the towns in and around the region.

Black Elk Peak is located southwest of Mount Rushmore and northeast of Sylvan Lake in the Black Elk Wilderness. Highway 244 crosses to the north, Highway 87 to the west, Iron Mountain Road to the east and the Needles Highway to the south. The easiest access is through Custer State Park at Sylvan Lake, although there is also access from several other trailheads, most notably Willow Creek Trail along Highway 244.

Sylvan Lake is in the very northwest corner of Custer State Park and can be reached by traveling the Needles Highway through the park. From the city of Custer, Sylvan Lake Road also provides access north to the lake, and from Hill City, Highway 87 south also leads to Sylvan Lake.

Once arriving at Sylvan Lake, there is large parking area and educational signs along the east side of the lake. There is a gift shop, lodge, campground and several cabins in the area along the west side of Sylvan Lake.

Positioned squarely in the middle of Black Elk Wilderness, the only access to the summit of Black Elk Peak is by hiking about seven miles round trip. A system of hiking trails crisscrosses Black Elk Wilderness, with several trailheads that can eventually lead to Black Elk Peak. The trailhead at Sylvan Lake is the most direct path and also the most heavily used.

Trail Number 9 begins along the east end of Sylvan Lake at an elevation of 6,145 feet. More than three miles traversed and 1,000 feet in elevation gain are needed to reach Black Elk Peak and the fire lookout tower.

A CASUAL STROLL

Beginning as a casual stroll through the pine forest at the east end of Sylvan Lake, the difficulty steadily increases as switchbacks attempt to ease the incline to the exposed granite peak. Gaining 1,100 feet of elevation, the trail proceeds 3.5 miles briefly through Custer State Park and then traverses through the Black Elk Wilderness in the Black Hills National Forest to Black Elk Peak.

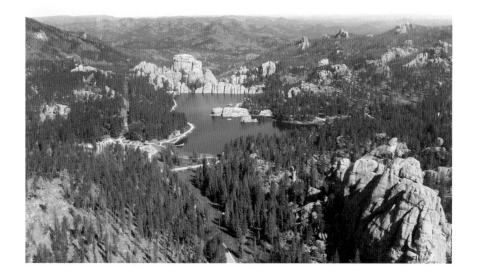

The trail to Black Elk Peak near the east end of Sylvan Lake has large safety and educational signs. *Photo by Bradley D. Saum.*

Opposite: The granite provides a dramatic backdrop for Sylvan Lake within Custer State Park, where the trailhead to Black Elk Peak begin. *Photo by Bradley D. Saum.*

Completely surrounded by the Black Elk Wilderness, Black Elk Peak is only accessible by traversing several miles on foot or horseback. Although there are several routes, Trail Number 9, originating at Sylvan Lake within Custer State Park, is the typical path to the summit. Thousands of visitors hike to Black Elk Peak each year, and during the summer months, it is typical to see many people along the trail.

In addition to the least strenuous, shortest and most popular Trail Number 9 from Sylvan Lake, there are several other hiking trails with different starting points. Palmer Creek, Willow Creek, the Cathedral Spires and Horsethief Lake all serve as trailheads for less traversed paths to Black Elk Peak. These alternate routes are longer and more difficult than the seven-mile round trip from Sylvan Lake.

As all the trails pass through Black Elk Wilderness, a Wilderness Use Permit is required for the trek. The permit is free and can be obtained in a self-service box located along the trail. The permit serves two primary purposes, providing the forest service with data about the number of people using the area and providing an opportunity to educate the public about the

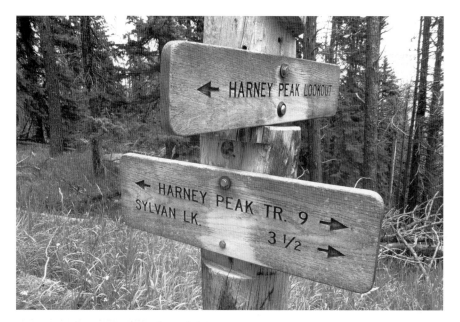

Trail Number 9 leading to Black Elk Peak is well marked and easy to follow for the hike from Sylvan Lake to the summit. *Photo by Bradley D. Saum.*

rules associated with the wilderness area, which are more restrictive than other forest service land.

The back side of the permit highlights the restrictions: no campfires are permitted, no motorized equipment is allowed, dogs must be controlled and there is no camping within one quarter mile of Black Elk Peak. Other reminders include packing out trash and following the switchbacks to avoid cutting new paths.

The trail consists of dirt, rocks, tree roots and the occasional wood or stone step inserted to control erosion and ease the ascent. Sturdy shoes are recommended to ensure good footing during the walk. The hike is moderately difficult, with steep inclines for most of the journey to the summit. The hike requires no technical climbing skills, and the round trip can be accomplished in four to five hours.

A glimpse of the summit can be seen from several rock outcroppings along the path, teasing the hiker. These make great places to stop and admire the unique view of the Black Hills, especially with all the granite outcroppings. The profile of the stone fire tower is easily recognized standing above the surrounding granite. A simple scan of the landscape between the vista and the lookout tower in the distance reveals the difficulty of the terrain that lies ahead.

Good footwear is helpful, as sections of the trail are intimidating as the ascent to Black Elk Peak progresses. *Photo by Bradley D. Saum.*

Although there is an elevation gain of just over **one thousand** feet during the hike to the peak, there are some relatively level areas that present quite an enjoyable stroll. *Photo by Bradley D. Saum.*

WILDERNESS USE PERMIT

- **PLEASE PRINT CLEARLY**
- **DEPOSIT THIS COPY IN BOX**

Visitor must have second page of this registration form
in possession during wilderness visit.

Party Leader Name

Leader Zip Code

Date Trip Begins

Date Trip Ends

Point of Entry (Trail)

Point of Exit (Trail)

Number of People Number of Stock Number of Dogs

Expected Destinations / Camp Locations

I agree to abide by all laws, rules and regulations which apply to
this area and will do my best to see that everyone in our group
does likewise.

Visitor's Signature *Date*

The purpose of this registration form is to (1) obtain accurate
wilderness visitor use data and (2) to educate visitors.

August 2010

A free Wilderness Use Permit is readily available at a box located as the trail enters into Black Elk Wilderness. *U.S. Forest Service.*

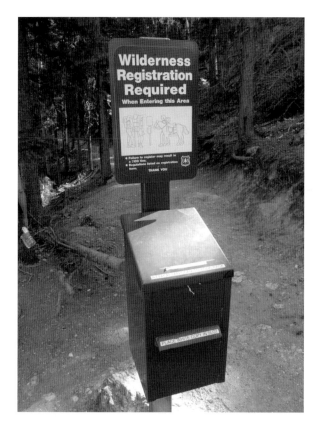

Left: The registration box for the Wilderness Use Permits is easily found along the trail and helps the U.S. Forest Service with traffic counts. *Photo by Bradley D. Saum.*

Below: The rock outcroppings make great resting places along the trail, and teasing glimpses of the lookout tower are visible on the distant peak. *Photo by Bradley D. Saum.*

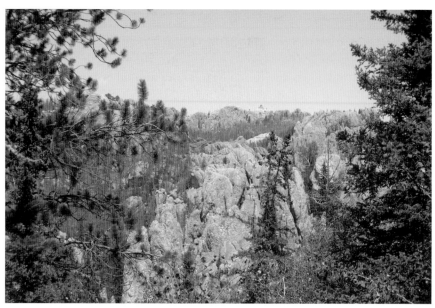

Above: The small wood footbridge crossing a stream is about the halfway point from Sylvan Lake to the summit of Black Elk Peak. *Photo by Bradley D. Saum.*

Right: Wearing proper footwear suitable for the rugged landscape makes for safer and more comfortable hiking experience to Black Elk Peak. *Photo by Bradley D. Saum.*

The trail to Black Elk Peak is in a wilderness area, and there are rocks and downed trees along the trail. However, the walking path is heavily used and well maintained. *Photo by Bradley D. Saum.*

To tired legs, hungry stomachs and sore muscles, the majority of people see the last scramble to the fire lookout tower as quite an accomplishment. The final stretch is really made possible by a staircase embedded in the granite, followed by stone steps to the lookout tower. The spectacular view from the summit is a significant reward for the hard work put into the ascent.

The admiration for the native stone structure built into the summit is quickly overtaken by the stunning scene that surrounds the peak. The mottled tones of the sporadic granite and widespread ponderosa pine trees of the surrounding hills extend for miles in all directions.

Since camping is prohibited within the quarter-mile area immediately surrounding Black Elk Peak, including no overnight stays at the abandoned fire lookout tower, the hike back down must begin. There is plenty of time for lunch, but only if it was packed in. There are no visitor services along the trail or at the summit. A few benches provide a comfortable rest stop, but there is no running water or food concessions in Black Elk Wilderness.

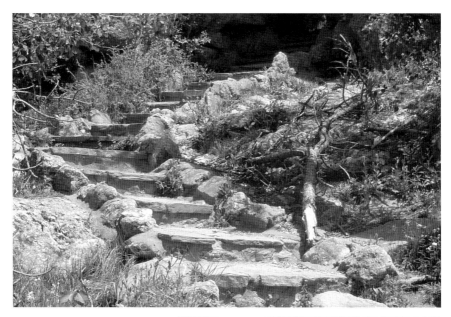

Above: The unavoidable steep inclines along the trail have been made slightly easier to maneuver with the installation of stone steps. *Photo by Bradley D. Saum.*

Right: Although General Custer made an attempt on horseback and later a wooden ladder was used to reach the summit, a steel staircase now provides the last little access to the granite summit. *Photo by Bradley D. Saum.*

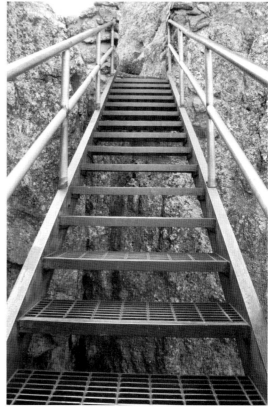

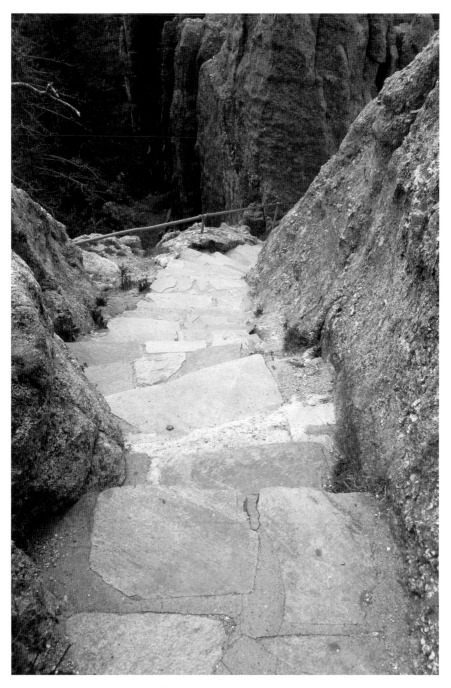

Stairs constructed of stone provide access along the steep granite slope to the entrance of the fire lookout tower at the summit. *Photo by Bradley D. Saum.*

A History

Black Elk Peak is a hidden gem because only an extremely small portion of all visitors to the Black Hills make the strenuous trek to the summit. There is no other way to see the remote stone fire tower or absorb the peaceful ambiance at the peak without the seven-mile hike.

BEST BEHAVIOR

The natural, historical and cultural significance of Black Elk Peak and the surrounding landscape is on a fulcrum in the midst of a balancing act. People are afforded the opportunity to access the area, but there is also a need to ensure that the environment is adequately protected and preserved for future generations.

The number of visitors making the trek through the Black Elk Wilderness to catch a glimpse from the highest peak and see the historic stone fire tower has been steadily increasing. This increase in use necessitates vigilance by everyone to minimize their impact to the natural and historic area.

Positioned squarely in public land with many designations, the Black Hills National Forest, Norbeck Wildlife Preserve and Black Elk Wilderness, along with the adjacent Custer State Park, all provide rules and regulations to help ensure that the people visiting the area take precautions to limit their impact.

Within the 13,426-acre Black Elk Wilderness that completely surrounds Black Elk Peak, camping is permitted, just not within one-quarter mile of the summit, which includes the fire lookout tower at the peak. Although camping is permitted in the surrounding area, no campfires are allowed. There is a risk of fire, and there is great difficulty in managing wildfires in remote wilderness areas. Even firefighters are required to attack the fire without the aid of vehicles, heavy machinery or mechanical equipment.

The trail from Sylvan Lake to Black Elk Peak is traversed by a large number of people, and the overall impact to the area can be minimized by simply staying on the established trail. This includes walking the switchbacks

on steep sections of the trail and not walking straight through as a shortcut, which can cause erosion issues. Trails are constructed in specific locations for visitor safety and the protection of natural resources.

Visitors to the fire lookout tower at Black Elk Peak have diverse levels of experience hiking in the wilderness. The trail to the summit is rugged, and rules are posted both for the safety of the visiting public and to ensure that the wilderness remains in its natural state.

Dogs are welcome to make the trek to the summit so long as they are on a leash or under strict verbal control at all times. It is quite a hike, and there is no plumbing to supply water, so both humans and dogs should bring an adequate supply of water.

All trash needs to be packed out. Waste should be disposed of properly, and things like empty water bottles should not be left along the trail or at the lookout tower. There are no trash cans in the wilderness, even along heavily hiked trails, so anything that goes in should also be carried out. There are trash cans at the trailhead near Sylvan Lake.

As part of the National Wilderness Preservation System, no motorized *or* mechanical vehicles are permitted, which includes bicycles, wagons and carts. In addition to vehicles, all types of motorized equipment are also prohibited.

There are many other rules and regulations that govern specific uses in designated wilderness areas and the Black Hills National Forest. Be sure to read signs, ask questions and inquire with the U.S. Forest Service about any unique activities.

For both the natural wilderness and the historic fire tower to remain intact for the enjoyment by people today, as well as for future generations, it takes the active participation of everyone to preserve and protect the resources. Dramatic steps are not needed for each person visiting the summit; just following the basic guidelines of staying on the trail, packing out all trash and having a minimal impact on the lookout tower and surrounding landscape is critical.

The "Leave No Trace" Seven Principles help guide people to enjoy the outdoors responsibly.

Seven Principles of "Leave No Trace"

1. Plan Ahead and Prepare
2. Travel and Camp on Durable Surfaces
3. Dispose of Waste Properly

4. Leave What You Find
5. Minimize Campfire Impacts
6. Respect Wildlife
7. Be Considerate of Other Visitors

© 1999 by the Leave No Trace Center for Outdoor Ethics: www.LNT.org

LOOKOUT PRESERVATION

The stone fire tower that has capped Black Elk Peak for more than eighty years is gradually showing its age. The impact of the harsh weather became noticeable, as the doors and windows were no longer in place to hold the rain and snow at bay. The aged masonry was in need of repair as well, as the structure is more than seventy-five years old.

Since 2012, the U.S. Forest Service has formally identified the need to preserve the historic structure and documented the plan for the preservation project. The following year, along with a cadre of volunteers, the U.S. Forest Service made significant progress with masonry repairs, as well as replacing doors and windows to shield the interior of the fire tower against the elements.

The National Historic Preservation Act of 1966 mandated the federal government realize a position of leadership in preserving and protecting historic sites. To fulfill this mandate, the U.S. Forest Service Historic Preservation Program engages a designated federal preservation officer to oversee the effort for sites such as the fire lookout tower on Black Elk Peak.

The U.S. Forest Service, in cooperation with the Forest Fire Lookout Association, maintains the National Historic Lookout Register in an effort to catalogue the historic fire lookout towers. This list recognizes the important role these lookout towers have provided in fire detection and wildfire management during the last one hundred years.

Within the Black Hills, there are five lookouts on the National Historic Lookout Register: Harney Peak Lookout, Custer Peak Lookout, Summit

Volunteers worked in 2013 to install nineteen replica windows in an effort to protect the lookout tower from the weather. *Black Hills National Forest.*

Doors and windows were replaced to preserve the lookout tower; only manual tools were used, in recognition of the Black Elk Wilderness Area. *Black Hills National Forest.*

Ridge Lookout, Elk Mountain Lookout and Rankin Ridge Lookout. Each of these lookout towers was strategically placed on high points to be able to effectively detect wildfires throughout all of the Black Hills.

The key to successful restoration is to maintain the original look of the tower as it was constructed in the 1930s. The design and architecture are remaining the same throughout the restoration, with repairs and maintenance being done to ensure the integrity of the structure and protect against future degradation.

This is certainly not a project where a few strokes of a paintbrush solve the problem. All of the windows and doors were missing from the structure, and the damage was gradually accumulating as the elements penetrated the building. Where windows once protected the interior of the structure from the weather, new windows that are similar in appearance to the originals are being installed. Doors are being added where the originals once provided protection. Any modern materials that are used to shore up walls for critical support are cosmetically hidden to ensure the tower's appearance is the same as when the original lookouts scanned the horizon for rising smoke.

The work is being completed true to the original design to maintain the historical integrity of the structure and respect for the wilderness. Situated

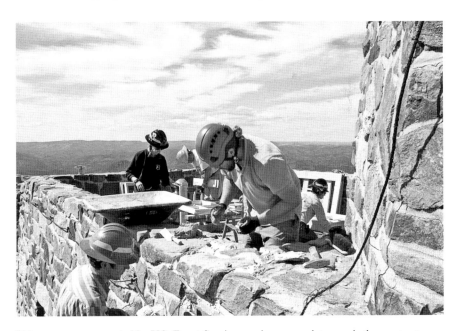

Volunteers, accompanied by U.S. Forest Service employees, work to repair the mortar to ensure that the fire lookout tower is preserved. *Black Hills National Forest.*

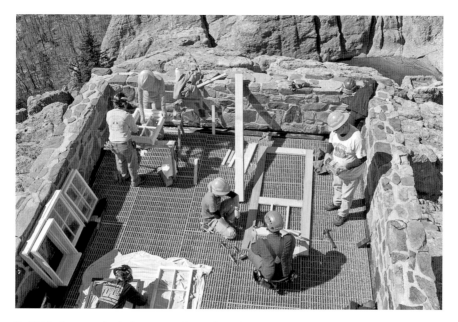

In 2013, doors and windows were the main priority to ensure protection from the elements. Preservation efforts have continued each fall for several years. *Black Hills National Forest.*

in the Black Elk Wilderness, where motorized vehicles are not permitted, the construction is proceeding without the aid of power tools and motorized equipment. Periodic improvements are noticeable each year as the structure is gradually fortified to prevent additional deterioration.

Based on the plan compiled in 2012, work will continue periodically for five years. With the initial replica windows and doors in place, work continues on the masonry, and eventually, the observation deck on the highest floor will be reconstructed.

In the same manner that the Civilian Conservation Corps maneuvered its equipment up the nearly four miles to Black Elk Peak, the present-day preservation projects utilize horses and mules to pack supplies to the summit. Windows, concrete, scaffolding and supplies of all sorts have been meticulously packed and transported by the Black Hills Country Horsemen and the Forest Service Region 2 mules. This local effort in support of public lands earned a Double Diamond Award from the National Back Country Horsemen of America.

The forest service employees and the accompanying volunteers still have a substantial amount of manual work remaining when the pack string of

mules reaches the hitch rail just below the summit. All the building materials and supplies must then be carried up the steel staircase between the granite and up the final stretch on stone stairs. At the conclusion of the work, all the tools and associated equipment must be carried down and packed out.

Slow and methodical preservation ensures that the iconic stone fire tower, which is listed in the National Register of Historic Places, remains solidly embedded on the summit for future generations.

EPILOGUE

For an unremarkable rock outcropping that just happened to ascend slightly higher than the surrounding granite 1 billion years ago, Black Elk Peak has an exceptional story to tell. Individually, each aspect of history that unfolded on Black Elk Peak combines to reflect a spectrum as colorful as a rainbow. Scattered throughout the pages of history, every interaction with Black Elk Peak merges to reveal a quite remarkable summit.

The high point is more than merely granite, more than a fire tower and more than any single event. Black Elk Peak encompasses a unique conglomeration of diverse people, cultures and experiences that have produced an historical enigma.

For a region that has been inhabited for thousands of years, the specifics of documented history are relatively brief, encompassing merely the last 250 years. With the attraction of Black Elk Peak and the way it is interconnected and collaterally related to so much history during those years, just imagine for a moment if we were able to definitely capture all the sights and sounds from the thousands of years before that. The Native Americans likely scanning the Black Hills from the high point, utilizing the summit for spiritual ceremonies, gaining an advantage in hunting and seeking an overview of the topography, as well as all the individuals who would reveal untold stories.

The high point has been a cordial stage, an elevated platform that originally drew Native Americans as a spiritual focal point. It has since appealed to myriad others seeking countless objectives. The role of Black Elk Peak continues to be deeply entwined in the culture of the Sioux.

The character of Black Elk Peak can be found in the spiritual essence of the Sioux culture. A history of stories, legends and experiences passed from one Native American to another across many generations provides insight into the importance of this region and, particularly, this one peak.

A spiritual location, Black Elk Peak serves as a sacred place. The revered ground generates a nearly palpable presence to those open to the divine encounter. The hallowed ground of Black Elk Peak is not referred to in the past tense as something that no longer exists. The Black Hills, and the highest peak, remain a significant place for the Sioux. Prayer cloths, offerings and ceremonies are an ongoing part of Black Elk Peak as centuries-old traditions continue.

With the new name in 2016, Black Elk Peak recognizes the historical significance of the peak and honors a spiritual leader closely associated with the summit. Nicholas Black Elk is a respected spiritual leader and revered among the Sioux.

The high-point claim has drawn many people to Black Elk Peak, and the lure is as varied as each curious individual seeking to place their feet on the summit. The granite protruding above the surrounding landscape was molded below the earth's surface billions of years ago. The high point now stands simply as an impressive geological feature.

The natural beauty is inspiring. The view is breathtaking. It is not just that Black Elk Peak stands as the highest elevation in South Dakota at 7,242 feet—the panoramic scene feeds the eye with endless opportunities. Many people believe that the harder someone works for something, the greater the reward and appreciation. A rather strenuous uphill trek—likely highlighted with some combination of sweat, deep breaths, muscle aches and perhaps joint soreness—forms the basis for a meaningful appreciation of the awaiting reward at the summit.

Even though it is quite a hike, it can be accomplished by most people regardless of hiking experience or past athleticism. The trail is somewhat forgiving to those who pace themselves. As with nearly any trail, there are those who jog to the summit, those who walk with flimsy flip-flops and those with hiking boots and a backpack with survival gear, as well as every possibility in between. A little preparation, sturdy shoes and bringing a snack and water along will enable the vast majority to summit the highest peak in South Dakota.

The view is absolutely spectacular and provides a complete panorama of the entire Black Hills region and beyond. Black Elk Peak presents a vantage point atop the granite summit unobstructed by trees. The combination

of granite outcroppings, pine forests and grassy plains provides a unique landscape in all directions as far as the eye can see.

The stone fire tower that extends above the granite summit is magnificent in design, architecture and execution. It is a piece of American history. The structure is a classic representation of President Franklin D. Roosevelt's New Deal. The toils of many people joined by a common desire to minimize the impact of the Great Depression created more than just a stone fire tower. An iconic landmark that is synonymous with Black Elk Peak was created and, with the restoration, remains a viable part of the overall landscape.

Beyond any doubt, the stone fire tower is a critical component of the Black Elk Peak experience. While one trudges several miles up and down the rugged terrain, the fire tower periodically appears in the distance as a target, a beacon. During the final push up Black Elk Peak, there appears the incredible fire tower in the middle of nowhere and surrounded by nothing but ponderosa pine forest for many miles in every direction. Rising above the 7,242 feet of Black Elk Peak to the fire tower observation deck only enhances the panoramic view that extends for many miles in every direction.

However incredulous, the lookout tower remains only one aspect of Black Elk Peak and not the sole purpose for notoriety. The stone fire tower is a snippet of history that left its footprint on the summit, albeit a significant snippet and footprint.

An innocuous peak in a rather inaccessible locale, combined with a rich history, generates a story that must be shared. From the actual granite peak forming billions of years ago through the drama of the present-day name change, the highest peak in the Black Hills is ripe with antiquity.

As a single peak casting its shadow on those who traverse the mountainous island of Paha Sapa rising from the plains, the granite summit has logged a thoroughly diverse history. Each of the various snippets has exposed glimpses of the high point, and collectively, Black Elk Peak is revealed. The natural, historical and cultural gem stands prominently in the Black Hills of South Dakota.

BIBLIOGRAPHY

Adams, George Rollie. *General William S. Harney: Prince of Dragoons*. Lincoln: University of Nebraska Press, 2005.

Ambrose, Stephen E. *Crazy Horse and Custer: The Parallel Lives of Two American Warriors*. New York: Anchor Books, 1996.

American Philatelist. "Summer and Winter Resort Post Offices." July 2000.

Archer, Jules. *Indian Foe, Indian Friend: The Story of William S. Harney*. New York: Crowell-Collier Press, 1970.

Aurora Daily Star. "Looks into Four States." March 23, 1923.

The Badger Hole in Custer State Park. Pierre: South Dakota State Historical Society, 1984.

Barnes, Jeff. *Great Plains Guide to Custer*. Mechanicsburg, PA: Stackpole Books, 2012.

Baskett, Tom, Jr., and Jerry Sanders. *An Introduction to Custer State Park*. Billings, MT: RAWCO, 1977.

Bear, Luther Standing. *My People, the Sioux*. Lincoln: University of Nebraska Press, 1975.

Beck, Paul Norman. *Columns of Vengeance: Soldiers, Sioux, and the Punitive Expeditions, 1863–1864*. Norman: University of Oklahoma Press, 2013.

Berkeley (CA) Daily Gazette. "Dr. McGillicuddy's Ashes to Be Put on Mountain Peak." October 3, 1939.

Bidwell, Laural A. *Mount Rushmore & the Black Hills*. Berkeley, CA: Avalon Travel, 2013.

Boyle, Dixie. *Between Land & Sky: A Fire Lookout Story*. Denver, CO: Outskirts Press, 2007.

Butler, Susan. *East to the Dawn: The Life of Amelia Earhart.* Philadelphia: Da Capo Press, 1997.

Carter, Robin Borglum. *Gutzon Borglum: His Life and Work.* Austin, TX: Eakin Press, 1998.

Civilian Conservation Corps Museum of South Dakota. "Civilian Conservation Corps (CCC) Harney Peak Memories from the CCC Museum of South Dakota, 2015-07-16." July 16, 2015. http://www.southdakotaccc.com/post.asp?read-about=harney-peak-memories.

Clark, Badger, and Camille Yuill. *Boots and Bylines.* Custer, SD: Chronicle Pub., 1978.

Clark, Badger. *Custer State Park.* Pierre: South Dakota Game, Fish and Parks Commission, n.d.

———. *Sky Lines and Wood Smoke.* Custer, SD: Hartman Printing, 1984.

———. *Sun and Saddle Leather.* Tucson, AZ: Westerners International, 1983.

Columbus Journal. "The Famous Black Hills Summer Resort." August 23, 1899.

Cornebise, Alfred Emile. *The CCC Chronicles.* Jefferson, NC: McFarland & Company Inc., 2004.

Custer, Elizabeth Bacon. *"Boots and Saddles," or, Life in Dakota with General Custer: With Portrait and Map.* Bowie, MD: Heritage Books, 1990.

Custer, George A., Elizabeth Bacon Custer and Marguerite Merington. *The Custer Story: The Life and Intimate Letters of General George A. Custer and His Wife Elizabeth.* New York: Devin-Adair, 1950.

Davis, Julie Hirschfeld. "Mount McKinley Will Again Be Called Denali." *New York Times*, August 30, 2015. http://www.nytimes.com/2015/08/31/us/mount-mckinley-will-be-renamed-denali.html?_r=0.

Davis, Ren, and Helen Davis. *Our Mark on This Land: A Guide to the Legacy of the Civilian Conservation Corps in America's Parks.* Granville, OH: McDonald & Woodward Pub., 2011.

DeVoto, Bernard. *The Journals of Lewis and Clark.* New York: Houghton Mifflin Company, 1997.

Domek, Tom. *Custer State Park.* Charleston, SC: Arcadia Publishing, 2004.

Egan, Timothy. *The Big Burn: Teddy Roosevelt and the Fire that Saved America.* Boston: Houghton Mifflin Harcourt, 2009.

Ellis, Jonathan. "Feds Change Harney Peak to Black Elk Peak, South Dakota's Highest Point." *USA Today*, August 12, 2016. http://www.usatoday.com/story/news/nation-now/2016/08/12/feds-change-harney-peak-black-elk-peak-south-dakotas-highest-point/88619676.

Ferguson, Jason. "Harney Peak Ties Recalled." *Custer County Chronicle*, June 4, 2015. http://custercountynews.com/cms/news/story-717547.html.

Fitzgerald, Tonie Jean. *Pine Bark Beetles*. Pullman: Cooperative Extension, Washington State University, 1994.

Fresonke, Kris, and Mark David Spence. *Lewis & Clark: Legacies, Memories, and New Perspectives*. Berkeley: University of California Press, 2004.

Froiland, Sven G., and Ronald R. Weedon. *Natural History of the Black Hills and Badlands*. Sioux Falls, SD: Center for Western Studies, Augustana College, 1990.

Gildart, Robert C., and Jane Gildart. *Hiking South Dakota's Black Hills Country*. Guilford, CT: Globe Pequot Press, 1996.

———. *Hiking the Black Hills Country: A Guide to More than 50 Hikes in South Dakota and Wyoming*. Guilford, CT: Falcon Guide, 2006.

Grant, R.G. *Flight: The Complete History*. New York: DK Publishing, 2002.

Griffith, T.D., and Nyla Griffith. *Insiders' Guide to South Dakota's Black Hills & Badlands*. Guilford, CT: Insiders' Guide, 2011.

Hall, Frederick. *Photo Point Monitoring Handbook*. U.S. Department of Agriculture, Forest Service, Pacific Northwest Research Station. Washington, D.C.: U.S. Government Printing Office, 2001.

Hamilton, David E. *The New Deal*. Boston: Houghton Mifflin, 1999.

Head, Marion L. *South Dakota: An Explorer's Guide*. Woodstock, VT: Countryman Press, 2009.

Heidler, David Stephen, Jeanne T. Heidler and David J. Coles. *Encyclopedia of the American Civil War: A Political, Social, and Military History*. New York: W.W. Norton & Company, 2000.

Hiltzik, Michael A. *The New Deal: A Modern History*. New York: Free Press, 2011.

Hogan, Michael. "Los San Patricios: The Irish Soldiers of Mexico." Chicago Indymedia, September 15, 2006. http://chicago.indymedia. org/newswire/display/73967/index.php.

Holler, Clyde. *Black Elk's Religion: The Sun Dance and Lakota Catholicism*. Syracuse, NY: Syracuse University Press, 1995.

Horsted, Paul. *The Black Hills: Yesterday & Today*. Custer, SD: Golden Valley Press, 2006.

Indexed Atlas of the World: Containing Large Scale Maps of Every Country and Civil Division upon the Face of the Globe, Together with Historical, Statistical and Descriptive Matter Relative to Each. Chicago: Rand McNally, 1883.

Jermann, Donald R. *Union General Gouverneur Warren: Hero at Little Round Top, Disgrace at Five Forks*. Jefferson, NC: McFarland & Company, 2015.

Jordan, David M. *"Happiness Is Not My Companion": The Life of General G.K. Warren*. Bloomington: Indiana University Press, 2001.

Korte, Gregory. "After Denali Name Change, Attention Turns to South Dakota's Harney Peak." *USA Today*, September 21, 2015. http://www.usatoday.com/story/news/politics/2015/09/20/after-denali-name-change-attention-turns-south-dakotas-harney-peak/71925332.

Larner, Jesse. *Mount Rushmore: An Icon Reconsidered*. New York: Thunder's Mouth Press/Nation Books, 2002.

Larson, Gary, and James R. Johnson. *Plants of the Black Hills and Bear Lodge Mountains*. Brookings: South Dakota State University, College of Agriculture & Biological Sciences, South Dakota Agricultural Experiment Station, 2007.

Leonard, Devin. *Neither Snow Nor Rain: A History of the United States Postal Service*. New York: Grove Press, 2016.

Lewis, Meriwether, William Clark and Frank Bergon. *The Journals of Lewis and Clark*. New York: Penguin Books, 2003.

Lodi News-Sentinel. "Texas Loses Out on Highest Peak." September 23, 1953.

Ludlow, William. *Report of a Reconnaissance of the Black Hills of Dakota, Made in the Summer of 1874*. Engineer Department, U.S. Army. Washington, D.C.: U.S. Government Printing Office, 1875.

Marshall, Joseph. *The Journey of Crazy Horse: A Lakota History*. New York: Viking, 2004.

McClintick, Lisa Meyers. *The Dakotas Off the Beaten Path: A Guide to Unique Places*. Lanham, MD: Globe Pequot Press, 2015.

McGillycuddy, Julia E. (Blanchard). *McGillycuddy, Agent: A Biography of Dr. Valentine T. McGillycuddy*. Stanford, CA: Stanford University Press, 1941.

McMurtry, Larry. *Crazy Horse*. New York: Penguin Group, 1999.

Moulton, Candy. "Mapping the Black Hills: Valentine T. McGillycuddy." *True West* (August 6, 2009). http://www.truewestmagazine.com/mapping-the-black-hills-valentine-t-mcgillycuddy.

National Geographic Guide to State Parks of the United States. Washington, D.C.: National Geographic Society, 2012.

Neihardt, John G. *Black Elk Speaks*. Albany: State University of New York Press, 2008.

Neihardt, John G., Black Elk and Raymond J. DeMallie. *The Sixth Grandfather: Black Elk's Teachings Given to John G. Neihardt*. Lincoln: University of Nebraska Press, 1985.

Nelson, McKenzie. "Historic Harney Peak Lookout Tower Continues Preservation Work." KEVN, Black Hills FOX, September 10, 2014. http://www.blackhillsfox.com/home/headlines/Historic-Harney-Peak-Lookout-Tower-continues-preservation-work-274688261.html.

Olsen, Brad. *Sacred Places North America*. San Francisco, CA: Consortium of Collective Consciousness, 2008.

Ostler, Jeffrey. *The Lakotas and the Black Hills: The Struggle for Sacred Ground*. New York: Penguin Group, 2010.

———. *The Plains Sioux and U.S. Colonialism from Lewis and Clark to Wounded Knee*. New York: Cambridge University Press, 2004.

Pritzker, Barry. *A Native American Encyclopedia: History, Culture, and Peoples*. New York: Oxford University Press, 2000.

Redden, Jack Allison, James Jennings Norton and Robert J. McLaughlin. *Geology of the Harney Peak Granite, Black Hills, South Dakota*. Denver, CO: U.S. Geological Survey, 1982.

Rezatto, Helen, and Rose Mary Goodson. *Tales of the Black Hills*. Rapid City, SD: Fenwyn Press, 1989.

Ridsdale, Percival Sheldon, ed. "A Concert on Harney Peak." *American Forestry* (January 1921): 599.

Rogers, Hiram. *Exploring the Black Hills and Badlands*. Boulder, CO: Johnson Publishing Company, 1999.

Ronda, James P. *Lewis and Clark Among the Indians*. Lincoln: University of Nebraska Press, 2002.

Rousch, Emilie. "Preservationists Buy Historic McGillycuddy House." *Rapid City Journal*, October 23, 2011.

Rust, Daniel L. *Flying Across America: The Airline Passenger Experience*. Norman: University of Oklahoma Press, 2009.

Sanders, Peggy. *The Civilian Conservation Corps: In and Around the Black Hills*. Charleston: Arcadia Publishing, 2004.

Sandoz, Mari. *Crazy Horse: The Strange Man of the Oglalas, a Biography*. Lincoln: University of Nebraska Press, 2004.

Shlaes, Amity. *Coolidge*. New York: Harper, 2013.

Smith, Chester M., Jr. "Summer and Winter Resort Post Offices." *American Philatelist* (July 2000): 626–49.

Smithsonian Magazine. "The Making of Mount Rushmore." October 11, 2011. http://www.smithsonianmag.com/history/the-making-of-mount-rushmore-121886182/?no-ist.

Steltenkamp, Michael F. *Nicholas Black Elk: Medicine Man, Missionary, Mystic*. Norman: University of Oklahoma Press, 2009.

Swan, Kenneth D. *Splendid Was the Trail*. 1st ed. St. Helena: Montana Magazine, 1993.

Taliaferro, John. *Great White Fathers: The Story of the Obsessive Quest to Create Mount Rushmore*. N.p.: Public Affairs, 2002.

Tallent, Annie. *Annie Tallent: Black Hills Lady Pioneer: Pioneer, Teacher, Writer.* N.p.: Dakota Graphics, 1987.

Taylor, Emerson Gifford. *Gouverneur Kemble Warren: The Life and Letters of an American Soldier, 1830–1882.* Boston: Houghton Mifflin Company, 1932.

U.S. Department of Agriculture, Forest Service. *Early Days in the Forest Service.* Washington, D.C.: U.S. Government Printing Office, 1944.

Warner, Ezra J. *Generals in Blue: Lives of the Union Commanders.* Baton Rouge: Louisiana State University Press, 1964.

Warren, Lieutenant Gouverneur K. *Lieutenant Gouverneur K. Warren's Preliminary Report of Explorations in Nebraska and Dakota, in the Years 1855-'56-'57.* Historical Division, Office of the Chief of Engineers, U.S. Army Corps of Engineers. Washington, D.C.: U.S. Government Printing Office, 1981.

Wert, Jeffry D. *Custer: The Controversial Life of George Armstrong Custer.* New York: Touchstone, 1997.

Wichita City Eagle. "Dispatch from General Custer." August 27, 1874.

Winger, Charlie, and Diane Winger. *Highpoint Adventures: The Complete Guide to the 50 State Highpoints.* Golden: Colorado Mountain Club Press, 2002.

Zumwalt, Paul L. *Fifty State Summits: Guide with Maps to State Highpoints.* Portland, OR: J. Grauer, 1988.

Index

ABOUT THE AUTHOR

Bradley Saum is an avid traveler and natural history enthusiast with a passion for writing and photography. He has developed an appreciation for the natural, cultural and historical gems around the country having served as a park ranger with the National Park Service, South Dakota State Parks and Ohio State Parks.

A graduate of the University of Dayton, Bradley has diverse work experiences ranging from wildland firefighting to federal law enforcement and senior level management positions with Fortune 500 companies. Bradley is a volunteer alumnus of the Student Conservation Association and also served as an outdoor education instructor.

Originally from Ohio, Bradley has lived in many different areas of the country and has traveled the United States extensively. The Black Hills of South Dakota have always been a special place, and capturing the true

essence of Black Elk Peak provides an opportunity for Bradley to share his appreciation for this unique and sacred ground.

Bradley has also had the opportunity to travel internationally, visiting fifteen countries across the globe. Highlights include seeing a Bengal tiger in India, walking atop the Great Wall of China and experiencing and interacting with all the various cultures so uniquely different.